Drawing with Crayons, Pastels, Sanguine, and Chalks

THE COMPLETE COURSE ON PAINTING AND DRAWING

Drawing with Crayons, Pastels, Sanguine, and Chalks

BARRON'S

English text © Copyright 1994
by Barron's Educational Series, Inc.
Original title of the book in Spanish is "Pintura a la Cera,
Pastel, Sanguina Creta y Collage"
© Copyright 1992 by Parramón Ediciones, S.A.
Published by Parramón Ediciones, S.A., Barcelona, Spain
First edition, January 1992

Author: Parramón Ediciones Editorial Team
Illustrators: Parramón Ediciones Editorial Team

All inquiries should be addressed to:
Barron's Educational Series, Inc.
250 Wireless Boulevard
Hauppauge, New York 11788

Library of Congress Catalog Card No. 93-37109

International Standard Book No. 0-8120-1931-8

Library of Congress Cataloging-in-Publication Data
Drawing with crayons, pastels, sanguine, and chalks.
 p. cm. — (The complete course on painting and drawing)
 ISBN 0-8120-1931-8
 1. Crayon drawing—Technique. 2. Pastel drawing—
Technique. 3. Blackboard drawing—Technique I. Barron's
Educational Series, Inc. II. Series.
NC855.D73 1994
741.2'3—dc20 93-37109
 CIP

Printed in Spain
4567 9960 987654321

Contents

■ "Painting" with sanguine crayons

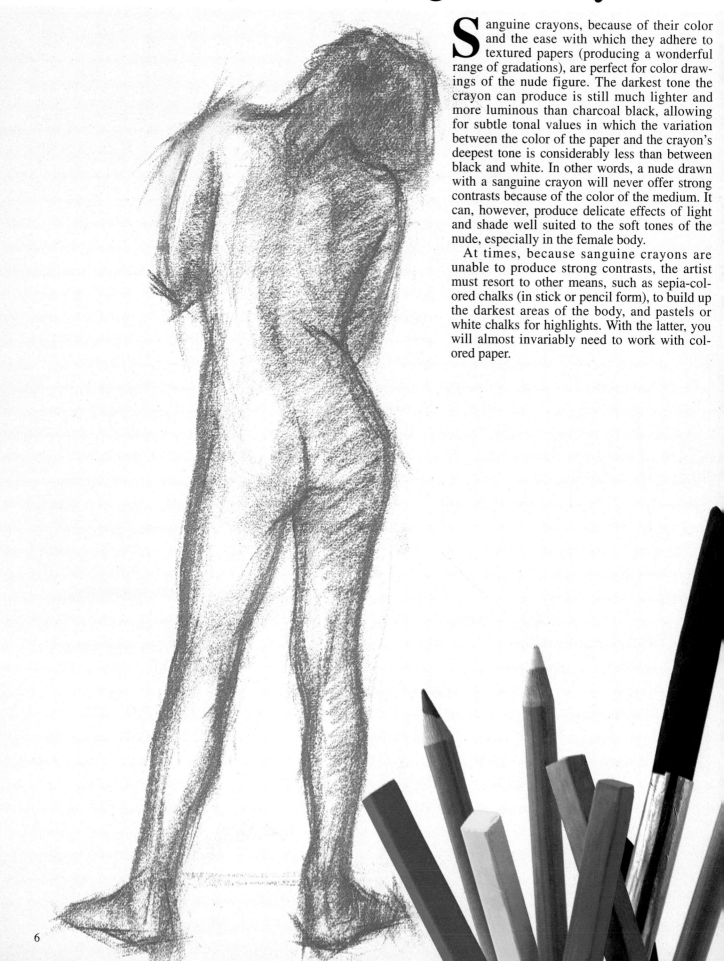

anguine crayons, because of their color and the ease with which they adhere to textured papers (producing a wonderful range of gradations), are perfect for color drawings of the nude figure. The darkest tone the crayon can produce is still much lighter and more luminous than charcoal black, allowing for subtle tonal values in which the variation between the color of the paper and the crayon's deepest tone is considerably less than between black and white. In other words, a nude drawn with a sanguine crayon will never offer strong contrasts because of the color of the medium. It can, however, produce delicate effects of light and shade well suited to the soft tones of the nude, especially in the female body.

At times, because sanguine crayons are unable to produce strong contrasts, the artist must resort to other means, such as sepia-colored chalks (in stick or pencil form), to build up the darkest areas of the body, and pastels or white chalks for highlights. With the latter, you will almost invariably need to work with colored paper.

Drawing the nude with sanguine crayon

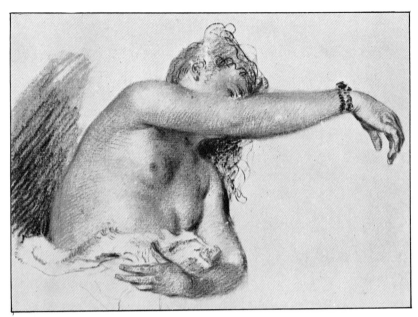

Some of the great masters of painting have found sanguine crayons (and other related materials) to be an excellent medium for their figure studies. Michelangelo, Leonardo da Vinci, Raphael, Rubens, Watteau, François Boucher, to name just a few of the great artists of the Renaissance and Baroque periods, made frequent use of sanguine crayons in their wonderful studies, many of which, thankfully, have been preserved for posterity. Innumerable famous artists, ancient and modern, used the sanguine crayon in their drawings of the nude. Here we will confine ourselves to just three masterly examples.

Left. *"Nude study," by Jean-Antoine Watteau. Sanguine and sepia-* *colored chalk on cream-colored paper.*

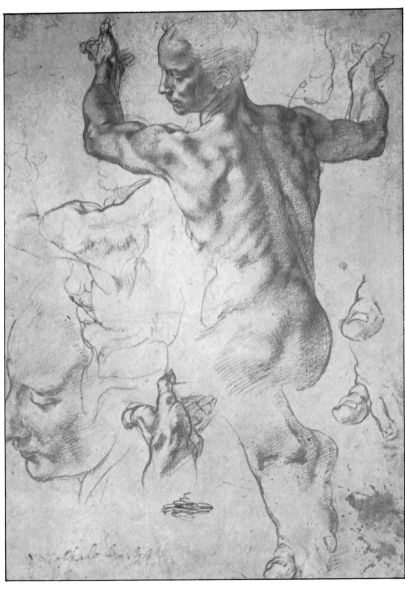

Left. *Impressive study in sanguine crayon of "The Sibyl of Lybia" by Michelangelo (Metropolitan Museum of Art, New York). In fact, this is a collection of studies on a single sheet of paper, in which the great artist made preparatory drawings before embarking on the definitive fresco painting.*

Above. *"Springtime figure," by Jean-Antoine Watteau. Sanguine, charcoal and white chalk on cream-colored paper. This is a very old technique that Watteau described as a* dessin a trois crayons *(drawing with three pencils).*

■ Female nude with sanguine crayon and sepia chalk

Choosing the pose

We will follow the step-by-step development of a study of the female nude drawn by Juan Sabater on Ingres paper, using sanguine crayon and sepia-colored chalk. Naturally, the eraser can also be added to the list of materials used by the artist.

We will start by looking at four sketches made using just sanguine crayon, based on four different poses. Each of the poses (all seen from behind) is interesting in its own way; however, Sabater chose the first one, feeling it was the richest in rhythm. It certainly does offer the greatest variety of curves, angles, and empty spaces. The artist felt that, of the four poses, it was the most striking.

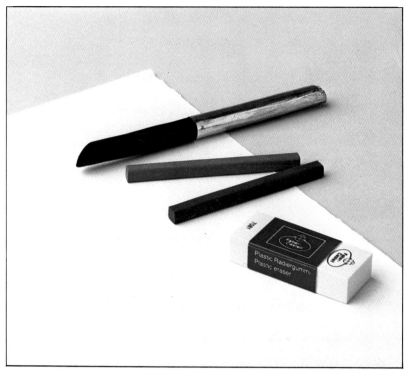

Below. In the artist's study, the model poses against a backdrop of white paper. Lateral illumination prevents the figure from projecting a shadow so it stands out sharply against the paper background.

Upper, right. The equipment used in this exercise.

Right. Four sketches of the same model in different poses. The main intention has been to capture the rhythmic lines of the body with broad, loose strokes and by suggesting light and shade.

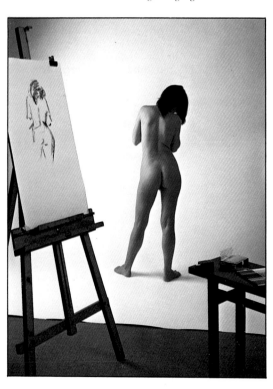

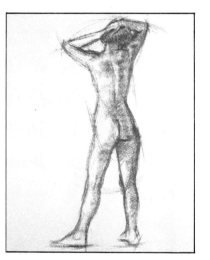

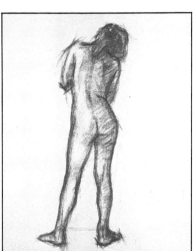

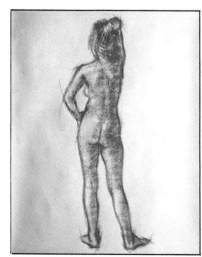

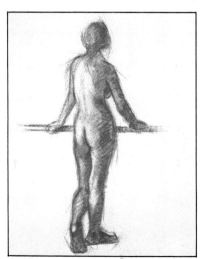

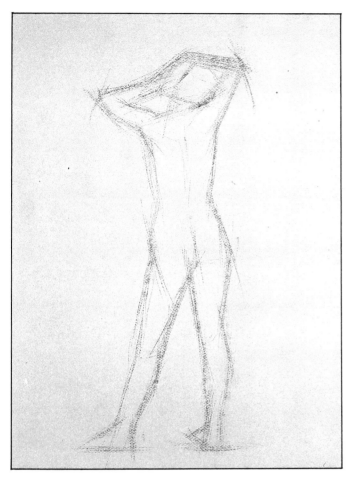

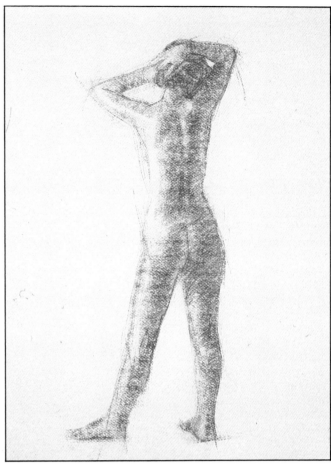

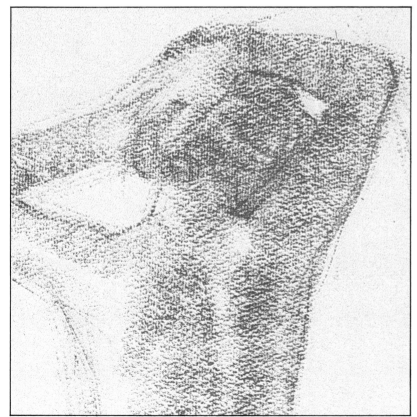

Outline sketch and first strokes

Notice that the sketch of the figure has been traced with very light charcoal strokes. It is important to produce such a sketch to guarantee easy removal of the black line and, above all, so that the sanguine color is not dirtied by an excess of charcoal dust. However, this light touch should not detract from the accuracy of rhythm and proportion.

Once satisfied with this initial sketch, Sabater proceeds to block in all the parts of the figure in shadow. Without pressing too hard, he has created a fairly uniform layer of base tone through which the texture of the paper can be clearly seen. However, even in this general tone, certain shades already suggest the most visible muscular forms.

Left. In this close-up you can see that, in spite of the simplicity of the first layer of tone, the artist has hinted at the forms of the deltoid muscles, the brachial biceps, and the shoulder blades.

Initial blending of the pigment

The objective is to work on areas of the sanguine crayon to draw out the characteristic qualities of the medium, and the delicate effect obtained when the material is engrained in the paper. To achieve this, there is no better method than using your finger as a kind of torchon. In this series of six close-ups notice the difference between areas of the picture before blending with the finger and then after the sanguine has become engrained.

In the examples on the right you see the velvety effect characteristic of the technique Sabater is demonstrating. When you proceed to this stage in your own picture, remember that the contours of the figure must not be lost. Always have the sanguine crayon handy to touch up any lines blurred by your finger.

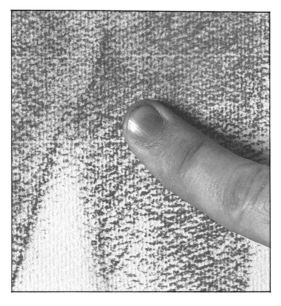

Right. Close-ups in which you see the velvety effect achieved when the finger is used as a torchon.

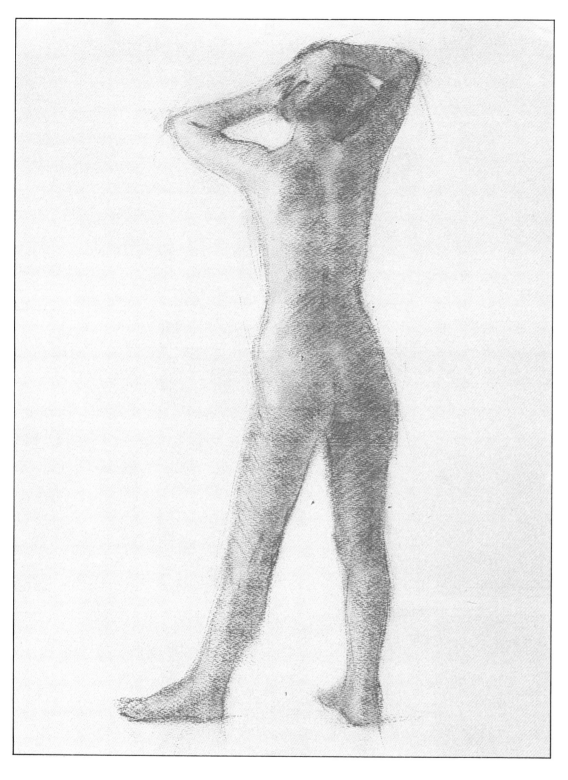

Left. Appearance of Sabater's picture after the stage described on the previous page. The darkest spots resulting from the grainy surface combine with the fainter tones created by the blending process to produce a more delicate effect, without completely losing the original texture of the paper.

11

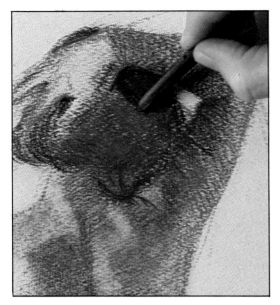

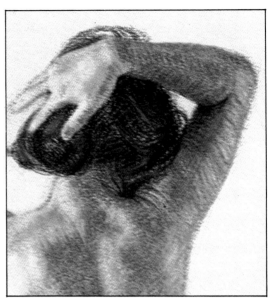

Final tonal evaluation

The previous stage prepared the way for the final process of using sanguine, chalk and the eraser to bring the work to completion. Sabater demonstrates here that sanguine and chalk, besides being perfect for conveying the color of the skin, can combine to produce finished work of high quality. Notice in this series of double close-ups that charcoal, sanguine crayon, chalk pencil, and the eraser were applied one at a time. The eraser was used not only for rubbing out, but also for drawing negative lines essential to form, and for giving sensitivity and vibrancy to the finished work. Also of great importance is the direction of the lines, which follow the curve of each of the surfaces they represent.

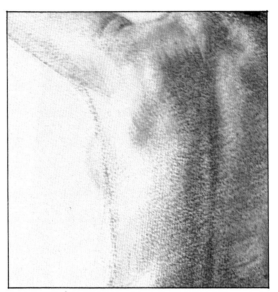

Left. Look at these three sections of the nude, before and after receiving the final touches. Sanguine crayon, chalk, and an eraser all contributed to the definitive appearance of each of the forms shown here.

Right. Notice in the finished work the importance of the direction of the strokes produced by the eraser.

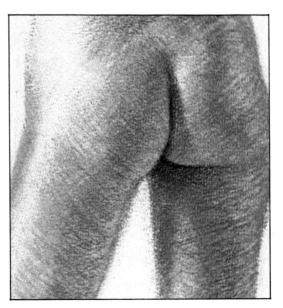

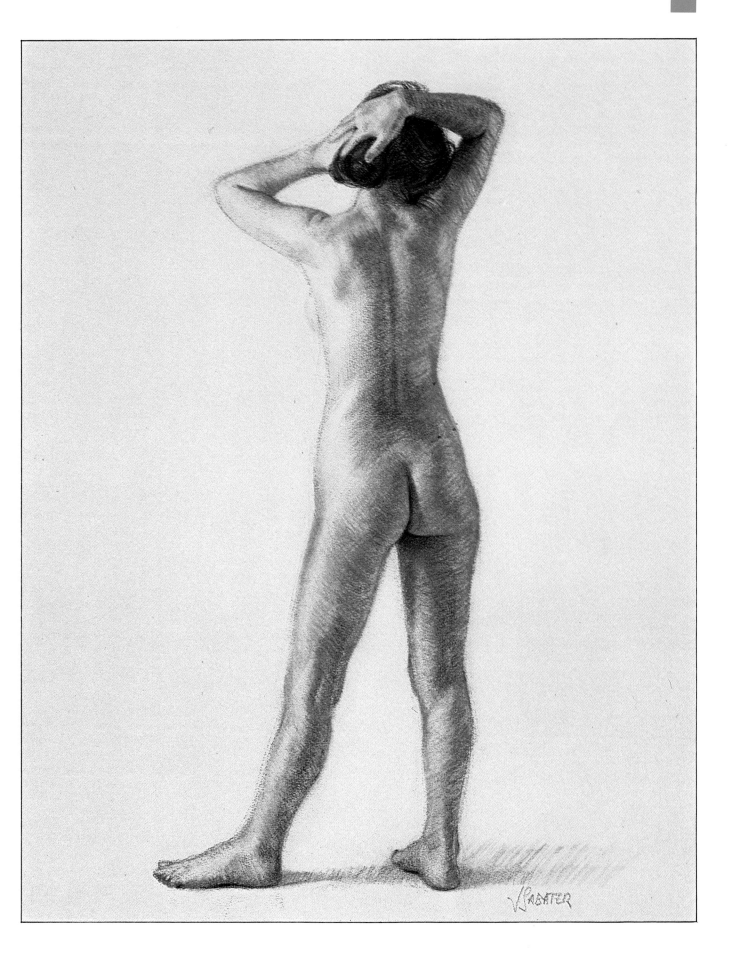

Reflecting on the art of portraiture

The most appropriate tribute to Diego Rodriguez de Silva Velázquez, one of the greatest painters and portraitists of all time, was to describe him as "The Painter of Truth." Truth is essential. Velázquez always painted the essence of his subject. Stated more philosophically, we could say his portraits revealed the essential personality, that quality without which his subject would not have been the person he or she was.

Those of us less familiar with painting might reply that Velázquez also included much detail in his portraits and compositions: The embroidery and lace of the clothing, the molding and carving of the furniture, and so on. This is, indeed, true.

But *how* he painted them is important. You must get close to the original works to realize that everything in them (even in what seems at a distance to be incredibly detailed work) is essential.

Veláquez's painting of Philip IV was, and continues to be, the ideal for portrait specialists: Paint the truth that is the very essence of each model's personality. The aim is not just to create a photograph with a paintbrush, although the student must initially work to represent what he sees. When you manage to recreate the physiognomy of your model on paper, you will be well on the way to following in the footsteps of masters such as Velázquez, Goya, and Tiépolo.

The history of art is full of masterly portraits and we recommend that you take an interest in this area of painting, if only through studying quality reproductions.

Perhaps it is time to start building a basic art library. This is necessary, even indispensable, not only to satisfy the natural thirst for knowledge of every cultured person, but also to justify one's own work. Naturally, this last consideration becomes important at a higher level of mastery of the medium. The beginner, though, has other, more immediate preoccupations.

On these pages we reproduced five impressive portraits and would like you to notice in each the interest the artist showed in the real person—even when the social standing of his subject must have created a dilemma for the painter.

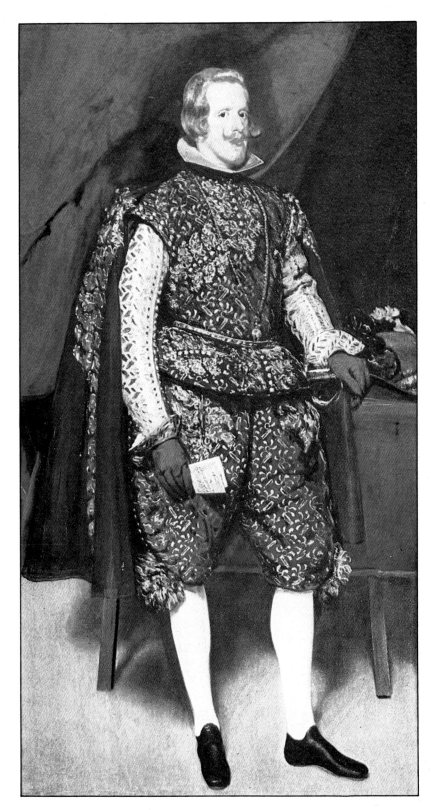

***King Philip IV.** Full-length portrait painted by Velázquez in 1632. Oil on canvas, National Gallery, London. Notice the extraordinary skill with which the details of the intricately patterned costume have been treated.*

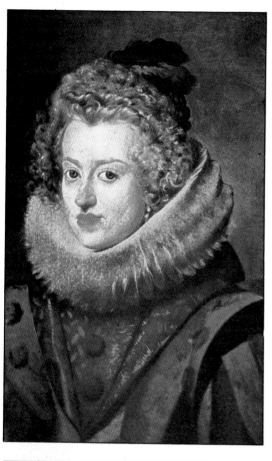

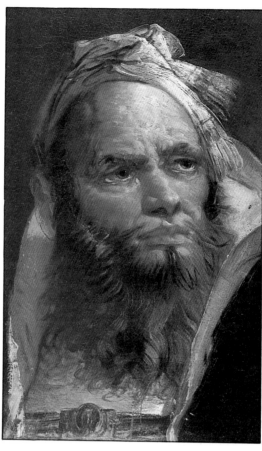

Far left. The Infanta Maria. Detailed sketch for a larger scale portrait completed by Velázquez in 1630. Oil on canvas, Prado Museum, Madrid.

Near left. Head of oriental man, by Giambattista Tiépolo. Oil on canvas, San Diego Fine Arts Gallery.

Below left. The Infanta Dona Maria Luísa. Francisco de Goya. Oil on canvas, Prado Museum, Madrid.

Below right. Don Juan Antonia Llorente. Francisco de Goya. Oil on canvas, Sao Paolo Art Museum.

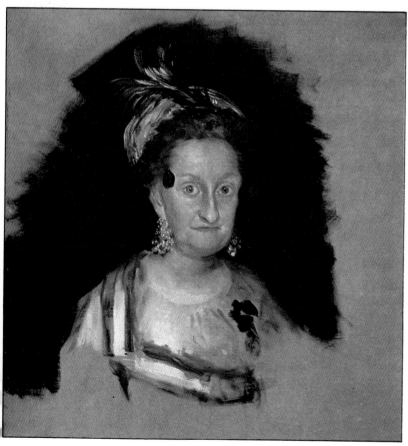

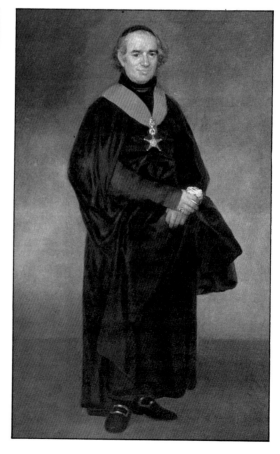

Composition in the portrait

Before beginning a portrait from life, the artist must deal with an initial problem: Composition. This can be divided into two elements: Positioning the model within the picture and establishing the pose. Positioning the head, even with the neck and shoulders, is not difficult. Follow these basic rules:

• When the model faces directly forwards, the head should be centered on the vertical axis of the picture (**a**).

• When the model is seen in profile or at an angle, the head should be positioned off-center, with more space in front than behind the nape of the neck (**b** and **c**).

Another thing to consider is whether to incline the head to one side, or upward or downward. On this point it is best to let the model adopt the position that comes naturally and spontaneously. In fact, the question of composition really begins only when making a half-length portrait. Composition is so important that most masters make a preliminary study of the pose, always guided by the individual characteristics of the model. Of course, doing a portrait of a politician or businessperson, will be a different exercise than portraying a teenager or a society matron. Finding the right pose is, as the artist Francesc Serra will demonstrate, a significant part of the process. Let's follow his train of thought:

1. Putting a young woman in a seated position, with one arm resting on the back of the chair, gives an air of langor to the pose, but creates a gap that focuses too much attention on the chair.

2. Moving the body closer to the chair back may solve this—but, no, that doesn't look right either.

3. By making the pose more natural, with her hands in her lap, we keep the oval rhythm of the arms, which works well. But now the right shoulder slopes the same way as the tilted head, and too much skirt shows in front of the hands.

4. That's it! Now the figure fills the picture: The left shoulder slopes, accentuating the rhythmic line of the neck; the oval shape formed by the arms, although visible, is less obvious because the left arm has been drawn back a bit. And the chair has disappeared completely. Now nothing distracts the viewer's eye. The languid pose remains, but within a more convincing composition.

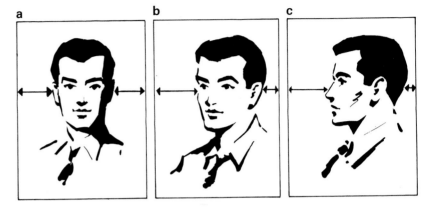

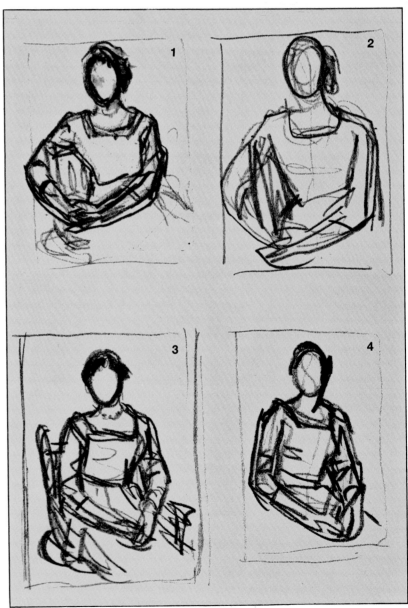

Portrait in sanguine crayon and charcoal

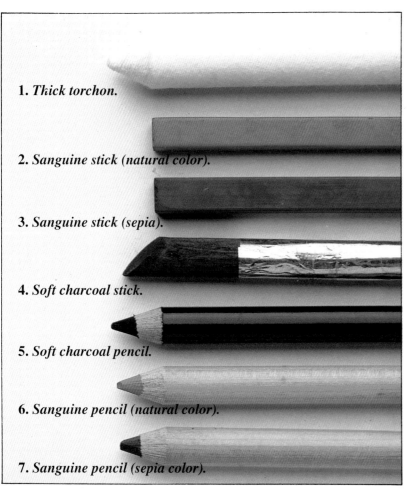

1. *Thick torchon.*

2. *Sanguine stick (natural color).*

3. *Sanguine stick (sepia).*

4. *Soft charcoal stick.*

5. *Soft charcoal pencil.*

6. *Sanguine pencil (natural color).*

7. *Sanguine pencil (sepia color).*

The materials

Remember that in art the medium determines the style. It is important to know the limitations of each material and not to demand what it cannot deliver—and vice versa. To achieve the results we want, we must identify the most appropriate medium. It is pointless to try to obtain intense grays with an HB pencil. If you are after strong contrasts, go for a 6B pencil or even charcoal. Remember that any idea you want to express visually has a medium best suited to it. It is absurd to show no interest in new materials. Discovering new techniques should be one of your regular pastimes. To inspire you in this respect, we propose a step-by-step exercise in which you interpret a photographic model. In your interpretation we would like you to combine all the materials you see in the photograph on the left.

Before starting, it would be a good idea to become familiar with these materials.

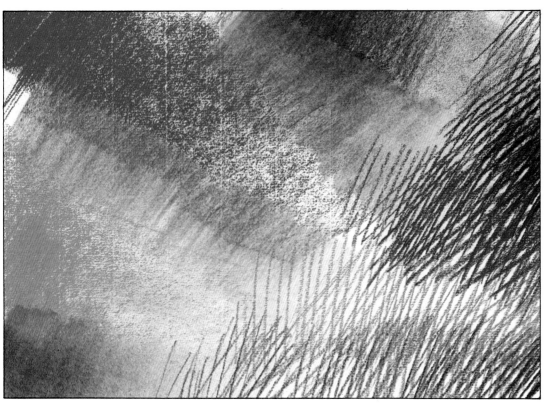

On a piece of fine-textured Canson water-color paper, experiment a little as we have done here. Explore the potential of each material separately and try for new effects and tones by superimposing two or more of them. Try blending pigment with the torchon and your fingers, or leaving the strokes unblended. Cover areas of the paper with vigorous cross-hatching. You will probably discover other methods of enriching a drawing with different pictorial qualitites.

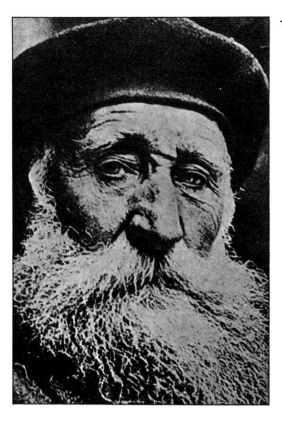

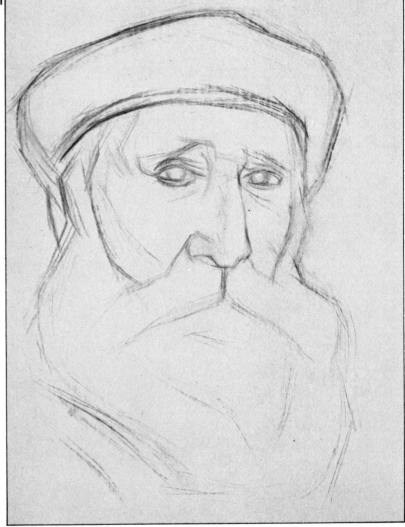

The model

This is a photograph of the great sculptor
Aristides Maillol (1861–1944). We thought it
was a good subject because of the combination
of dark areas in his beret, the background and
the shaded parts of his face, and the other two-
thirds of the picture comprising the pale tones
of his face and his white beard.

Sanguine crayons and charcoal soften the
general aspect of the portrait, without sacrific-
ing the possibility of an intense black where
necessary. Let's see how it's done.

The process

1. Use fine-textured Canson watercolor paper
of a pale, warm tone—a pale sienna, for
instance, works well with sanguine. The idea is
to find a background color that provides a
medium tone to guard against excessive con-
trasts.

With a charcoal stick, start your outline
sketch. Use very light strokes at the beginning
to avoid damage to the paper. Only when you
are sure of the features should you make them
definitive, as shown in the close-up on the
right. Notice that, even in the definitive sketch,
we have avoided vigorous strokes. We do not
want an excess of charcoal dirtying the san-
guine we are about to add.

2

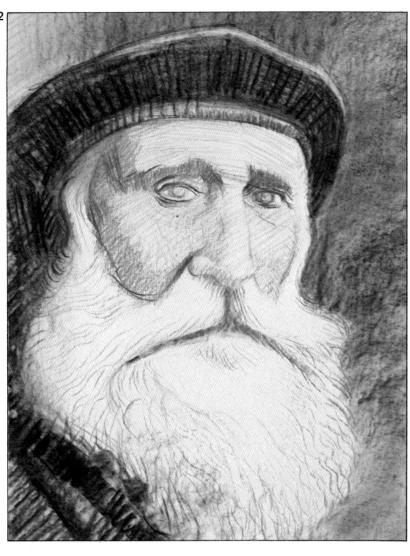

2. Using the sepia sanguine crayon stick, cover the surface of the face with soft, slanting strokes. You can also hint at the shading of the eyebrows, the nose and the darkest areas of the cheek and temple. Black in the background and the beret. Notice that in the beret and in the bottom left-hand corner a background tone has been established. Dark, directional strokes have been applied on top of this to help describe form. With the charcoal pencil, go over the outlines of the eyes, adding some shadow beneath the eyebrows. On the cheek, indicate the division between the beard and the chin, and draw in the lines of the mouth beneath the great moustache. Using the sienna sanguine pencil, trace the short wavy lines that suggest the hair and beard. Pay particular attention to the direction of these little strokes.

To help you see more clearly the application of the crayon sticks and pencils, we have added close-ups of the cheek and the left eye.

The torchon has been used to soften the gray of the background.

3. The final stage begins. The background is worked on with the sepia sanguine stick, so that, when mixed with the gray of the charcoal, we achieve a medium tone with tinges of violet. Then the natural-colored sanguine stick is used to draw strokes across the entire beret. These lines tone down the contrast between the beret and the face.

After this stage, the natural-colored sanguine is used extensively to define the various forms of the face. Notice that the artist has paid careful attention to the direction of the strokes. The beard has been enriched with strokes of sepia (and some of charcoal on the lower parts) except in the areas where the light falls directly. In these areas the pure color of the paper is allowed to show through. At this point we embark on the final stages of the picture.

4. Look at the close-up photos showing the last stages: The eyes have been outlined in black with the charcoal pencil; the charcoal stick has reinforced the contrast at the base of the beard between the white hair and the dark clothing; and sanguine and charcoal have been used together on the beret, to achieve a balanced tone. You can also see where the eraser has been used: For instance, as shown in the fourth close-up on this page, to blur the charcoal line at the base of the beard which had been too sharply defined.

The natural-colored sanguine pencil was used in conjunction with the charcoal pencil to sharpen up the profiles and contrasts of the eyes and nose. Try to imitate this in your own version of the drawing.

The left side of the head has been built up with the charcoal pencil and, following Leonardo's example, the background has been darkened adjacent to the lightest part of the picture on the right side. All these touches help to make the face and beard the center of interest in the composition. As you can see in the finished work (opposite page), our gaze goes instinctively toward the eyes, which is appropriate in a portrait showing only the subject's head.

3

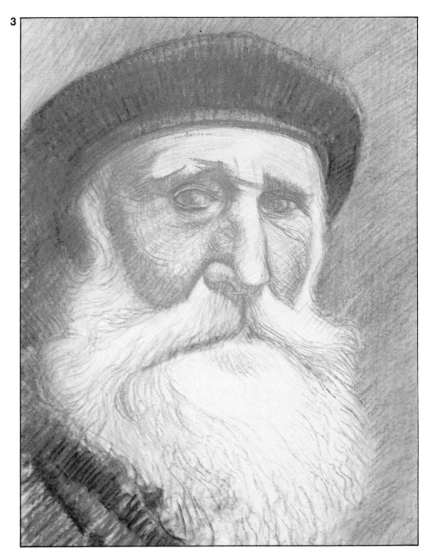

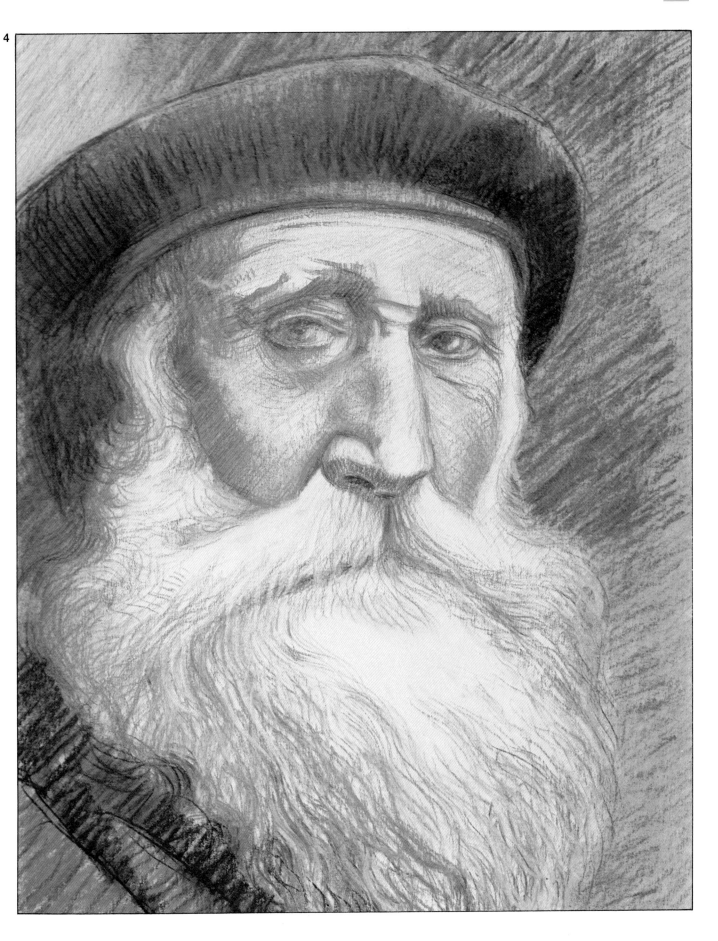

Sanguine crayons and colored chalks

In this section, we continue to work with sanguine, colored chalks, and charcoal used in combination. We are going to explore further the possibilities offered by these media by creating a colorful theme: This time a landscape.

Sanguine crayon, which we earlier saw used in the magnificent figure studies of some great Renaissance and Baroque artists, was also greatly valued by many artists inspired by the Baroque and Neoclassical periods (end of the 16th century and beginning of the 20th). In their studies of landscapes, real or imaginary, there always appeared some ruin reminiscent of the Roman era. In these works, we can see that sanguine (sometimes in combination with chalks of a darker tone) is a medium that, thanks to its high quality and flexibility, can produce landscape drawings of considerable sensitivity. We hope that, by following the exercise, you will reach the same conclusion and that, as a result, you will count it among the techniques you readily use when interpreting a landscape.

Landscape in full color

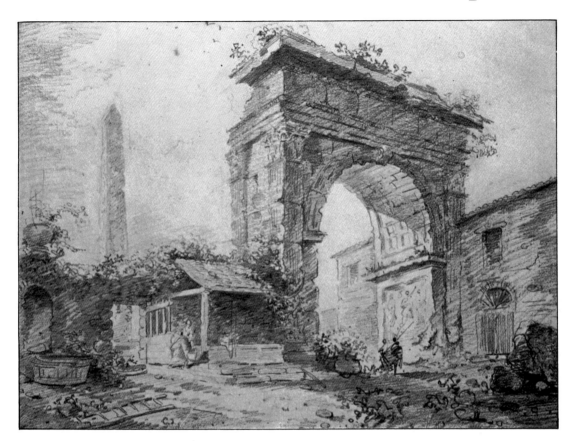

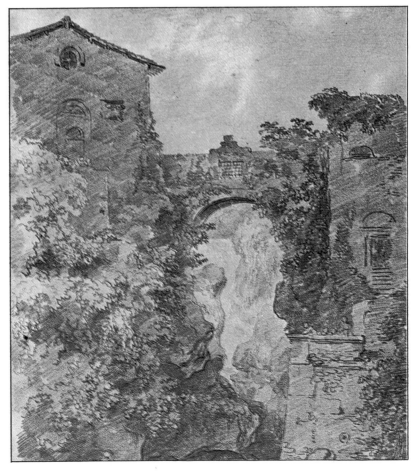

Left. Landscape study, very typical of its time, showing the allegorical ruins of a bygone age. Drawn in sanguine by Hubert Robert (1733–1808), Boymansvan Benmingen Museum, Rotterdam.

Below. This is a sanguine drawing by Jean Honoré Fragonard (1732–1806). It shows "The great Tivoli waterfall, seen from beneath the bridge," which is held by the Musée des Beaux Arts, Besançon.

Above. Let's leave the 18th century behind and return to our times, when mixed media techniques seem to be fashionable. Here is a landscape drawn with sanguine, chalks, and colored inks by the artist Ester Serra.

This leap in time and technique demonstrates the extreme versatility of the medium we are studying when it is used to interpret aesthetic concepts of an avant-garde nature.

The photograph

This time, Juan Sabater proposes that you work from a color photograph. This is not because he thinks this is the ideal way to paint a landscape but because he is sure that a color photograph need not be just something to copy (such an exercise could hardly be called artistic creation). The photograph is a starting point for seeing something from a fresh perspective, for adapting form, composition and color to convey an aesthetic idea, or to compensate for deficiencies in the original photograph. We should state right away that Sabater's only objective on this occasion was to create a traditional landscape drawing without any intellectual overtones. However, if we analyze the photograph with the eye of an artist, it quickly becomes obvious that Sabater will have to make some major modifications in the area of color. A cold tone in the photo completely dominates every part of the composition and gives it a rather unappealing monotony of color.

We recommend that you follow Sabater's example and, using this photograph or another of your choice, create an individual artistic interpretation, with the photo as a reference.

Right (opposite page). Sketch of the subject. Notice the sharp lines Sabater drew to define the edges of the planes of the building and also how he has outlined the shadows of the tree in the foreground. There is nothing unnecessary in this sketch—and yet nothing is missing either. Everything is where it should be.

Right and below (opposite page). Sabater's picture with the first areas of color have been blocked in. Note the division between the totally cold area of shadow in the foreground and the receding planes in which, apart from brilliant white, warm tones have appeared.

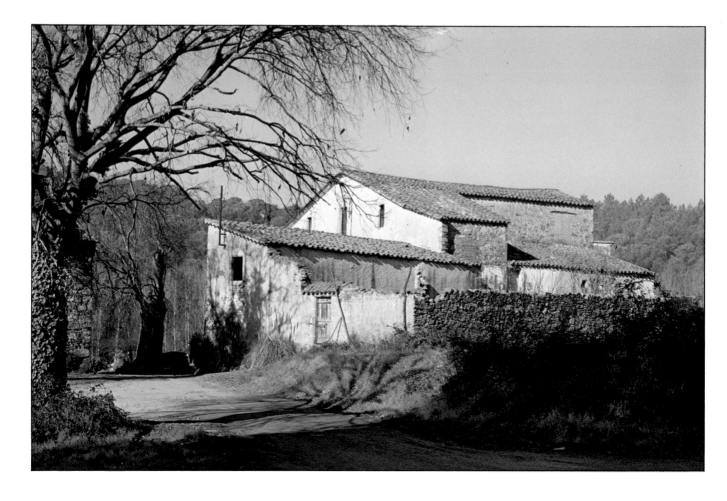

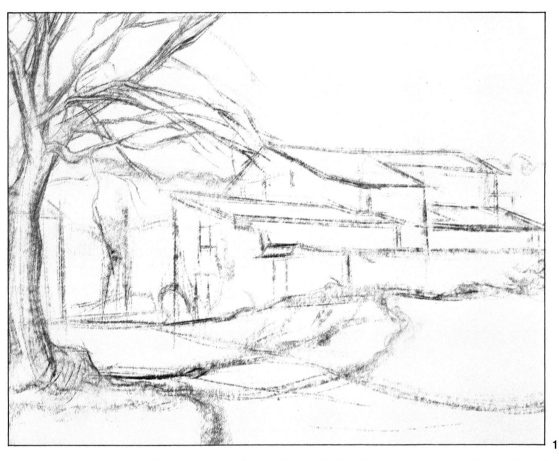

1

1. The sketch

On Ingres paper about 14 × 19 in. (35 × 50 cm), make an initial charcoal sketch, paying careful attention not only to the proportions and perspective of the main forms, but also to the direction of the shadows projected onto the different surfaces. In this picture, as indeed in many landscape paintings, shadows are often a vital part of the composition.

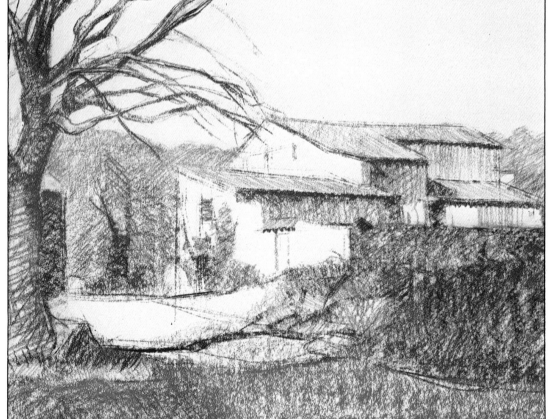

2

2. Initial color

Using dark tones, indicate the areas of the drawing where cool color will dominate, separating them by use of tonal contrast from the more luminous zones (the white walls of the old country house). This helps establish at an early stage the general appearance of the picture.

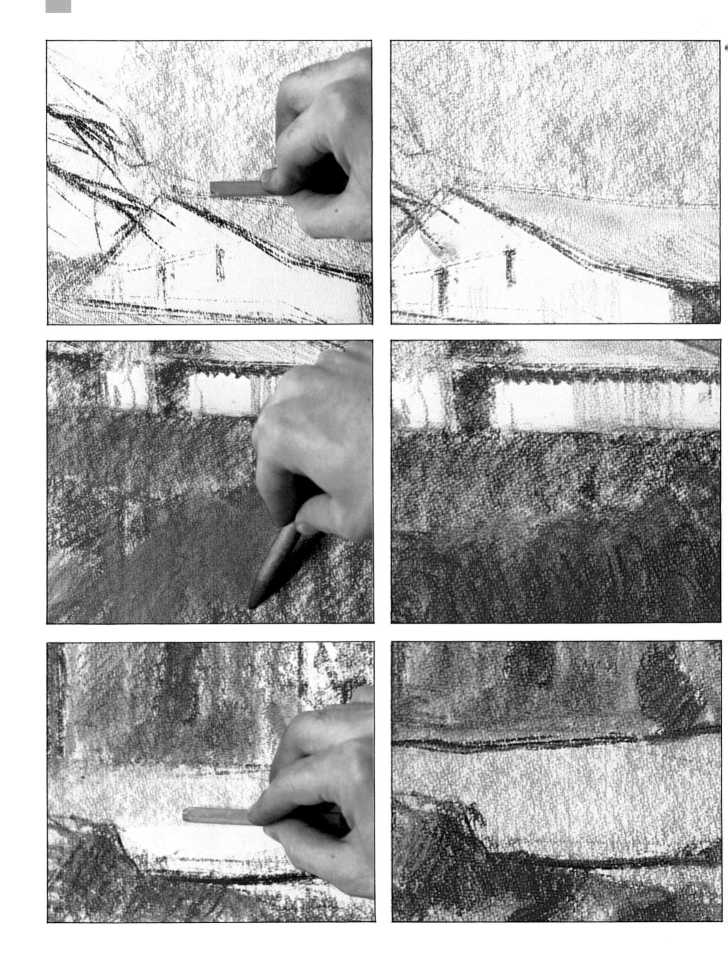

3. Warm-cool contrasts and contrasts of texture

This example will demonstrate how to use the texture of the paper in conjuction with the torchon to produce areas where the grain of the paper is visible and others where the pigment has completely penetrated the rough surface. On the left (previous page) are three pairs of photographs; in the classic "before and after" style you can see close-ups of the picture.

A. Part of the sky and the roof of the house with no color blending. The vibrancy afforded by the white of the paper showing through the pigment is evident. In this area there are no contrasts other than those caused by the impact of a cool tonal value beside a warm one.

B. Close-up of the foreground where Sabater combined the texture produced by the grain of the paper with that obtained by blending the

bluest part of the shadow, causing the pigment to sink into the grain and completely cover the surface. Another kind of contrast has been created here: That of two different textures in juxtaposition.

C. In this part of the road, there are two types of contrast: A marked contrast between warm and cool (warm light and cool shadow) and the background (which has been worked with the torchon) with its ochre plane for the road itself and where the grain of the paper is still revealed. At the end of this third stage of Sabater's picture, you can see that the artist has begun to introduce warmer colors into areas that are cool in the photograph, such as the background, or the tree in the foreground.

Below. The picture after the introduction of warmer tone and after establishing both those areas that will show the texture of the paper and those in which the pigment will be blended.

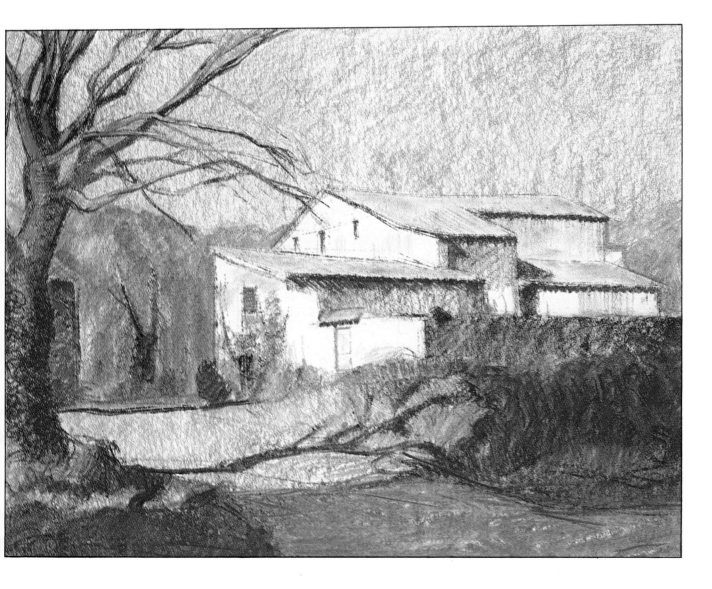

4. Final stage of the picture

After completing the stage shown on the previous page, you must, as Sabater has, work on building up the color and tonal values of each part of the landscape. Decide whether, as in our example, you need to accentuate the warmer tones or if the colder hues should be intensified. Obviously, the latter will apply if reds and yellows are too dominant in the photograph you have chosen.

Note how, for example, in close-up **A** on this page, the clearly greenish tone of the branches on the big tree (look again at the original photograph on page 24) has become a much warmer color.

The same thing has happened with the background (see close-up **B**), which has taken on a color somewhere between blood red and sepia, considerably altering the coolness of this area in the photograph. Looking at the shadows, in close-ups **B** and **C**, you can see that the artist has put a lot more into his picture than he could see in the photograph. In the photo, the shadows are a flat, uniform color. In the artist's version, although the prevailing coolness of tone remains, the shadows appear to be more luminous because they contain more color or, to be precise, warmer pigments.

Analyze the way Sabater treated the roofs; he started with an even ground, predominantly ochre in color. On top of this he drew short, wavy lines with sepia-colored chalk and a few lines of white chalk, managing to give a convincing impression of an Arab-tiled roof, without introducing unnecessary details. The roof glows with colors ranging from yellow ochre to luminous orange, reflecting the radiant, golden light of the Mediterranean sun.

Notice also, in the photo of the finished picture (on the next page), the difference between the broad area of shade in the foreground, as seen by the artist, and its appearance in the photograph. What was a uniform patch of shade in the photo, became one of the most interesting parts of the picture. The warm colors of the sunlit ground are flecked with a complementary dark blue, which in turn is enriched by splashes of black and more luminous strokes of green and white that suggest the tufts of grass on the edges of the road.

Finally, look at close-up **D**, on the next page, and observe how to use white chalk pencil to highlight indistinct details in a more or less uniformly colored background. In this case, the white pencil defined the old trunk of a dead tree and the shapes of those in the thicket in the background.

A

B

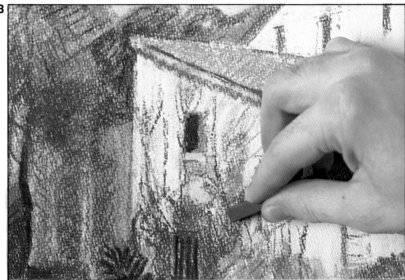

C

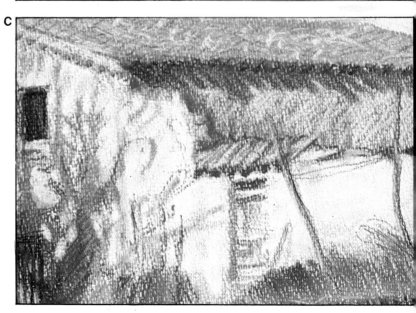

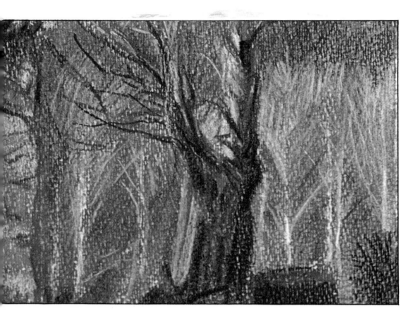

Also note how white chalk was used to illuminate the upper or left sides of the branches on the tree in the foreground, taking into account the position of the sun.

Left. *Close-up showing how the white chalk pencil was used to highlight the trunk of the dead tree and to define the trunks of the trees in the thicket.*

Below. *Juan Sabater's picture is offered to you as an example, in the hope that you will be inspired to produce your own landscape using sanguine crayons and chalks.*

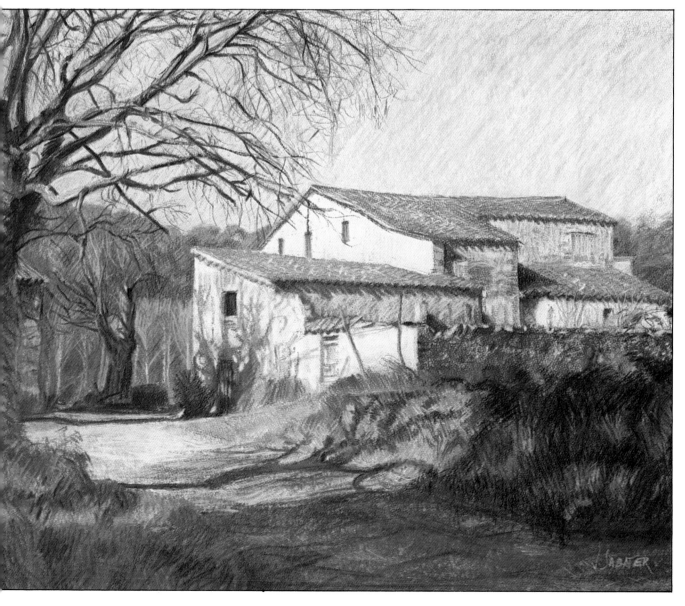

Female nude

The significance of the female nude as a subject for artistic creation has been enormous. Since time immemorial, the female body has been used as a symbol of beauty and still represents a constant challenge to those seeking new means of visual expression. Above all, the female nude is a sublime subject through which the artist can express an appreciation of beauty.

On these pages you will be introduced to drawing the female nude using techniques that are within everyone's grasp and that are on a small enough scale so any enthusiastic beginner can feel confident imitating them.

Confidence! The first obstacle to overcome is your own inhibitions; knowing that you are going to attempt a difficult but extremely rewarding subject. Colored pencils, chalks and sanguine crayons, a charcoal stick, white paper and neutral-colored paper: This is what you need to make a start.

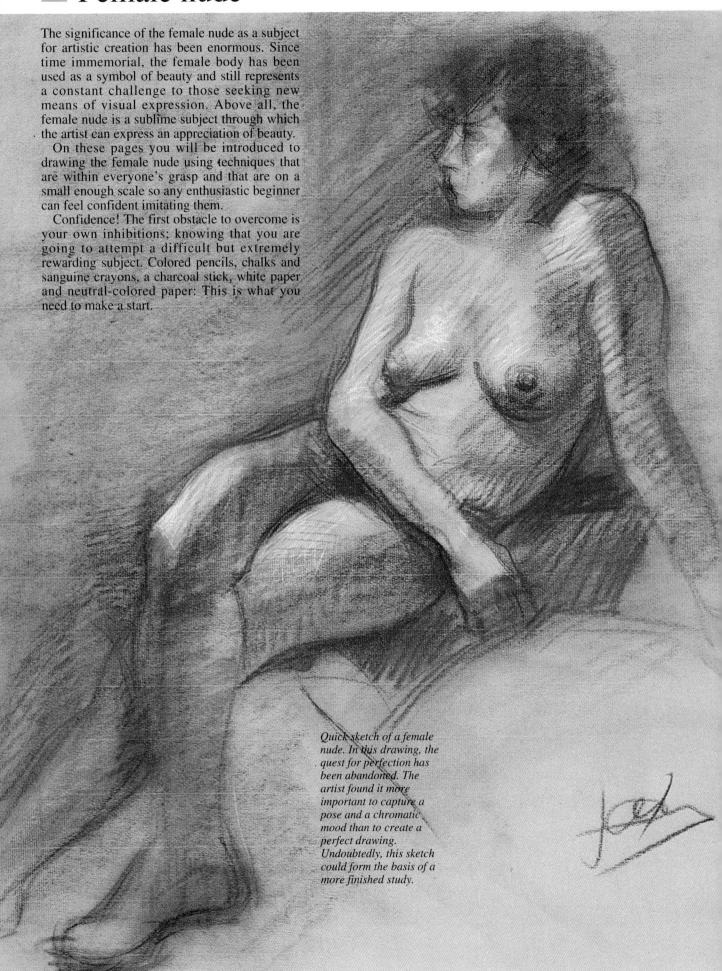

Quick sketch of a female nude. In this drawing, the quest for perfection has been abandoned. The artist found it more important to capture a pose and a chromatic mood than to create a perfect drawing. Undoubtedly, this sketch could form the basis of a more finished study.

Four studies by Ferrón

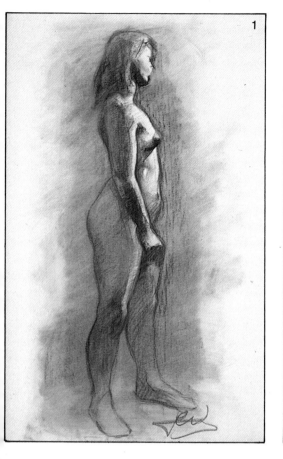

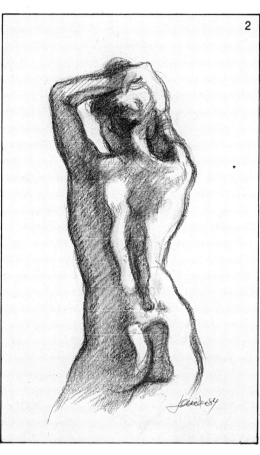

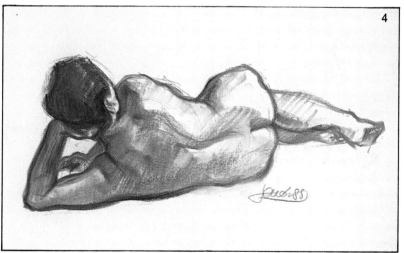

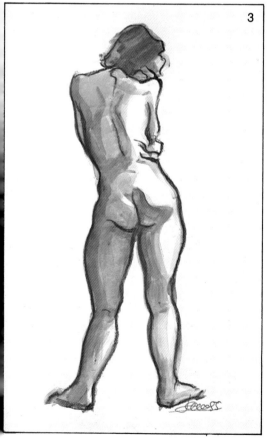

1. Study in sanguine crayon and blue and white chalk. Notice the emphasis the artist placed on the distinctive female attributes of the model.

2. Classic sketch in crayon on lightly textured paper. There is an obvious rhythm in the line of the curving spine and the extravagant slant of the right hip and buttock.

3. Sketch in sanguine crayon (the outline and lines of the spine and the buttocks) and watercolor. The pose adopted by the model demands a certain muscular tension, reflected in the vigorous line and precision of the darker brushstrokes.

4. Sketch in sanguine and sepia watercolor. Of particular interest is the acute foreshortening.

Studying the pose

When studying a pose or movement, it is useful to work from the diagrams of the human body seen on this page.

1. An upright, static position comprised of three sections: The head, the trunk and the pelvic region, with the extremities indicated by a suggestion of their skeletal structure.

2. Without losing sight of the "eight heads" rule, our doll-like figure is now given movement. Notice how it walks: Always remember the opposing slant of shoulders and hips.

3. Look at the diagrammatic representation of four characteristic poses: Relaxation, attention, meditation and waiting for something.

4. Analyze, through our diagrams, the different stages of running; in your sketches, try to achieve the sense of impetus created by the arms and the inclination of the trunk and head, which is always projected forward.

5. Once you memorize this diagrammatic rendering of the human body, you will be able to use it to express any pose and any movement. The usefulness of working from this diagram becomes clear when you draw greatly foreshortened poses.

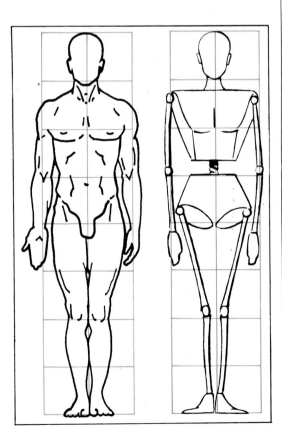

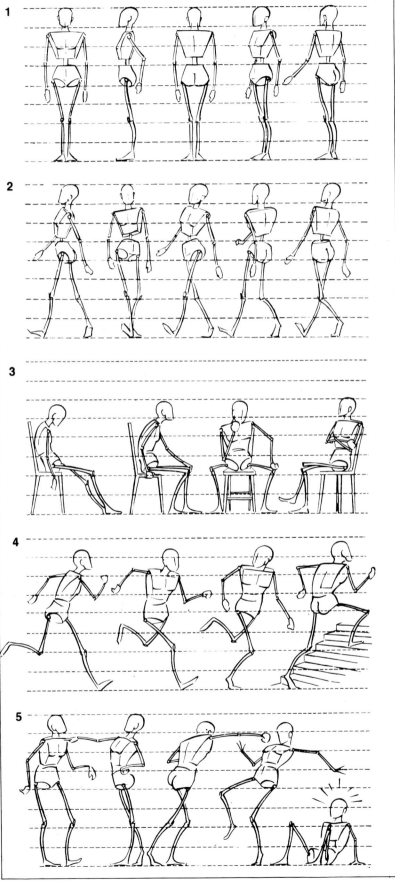

Poses

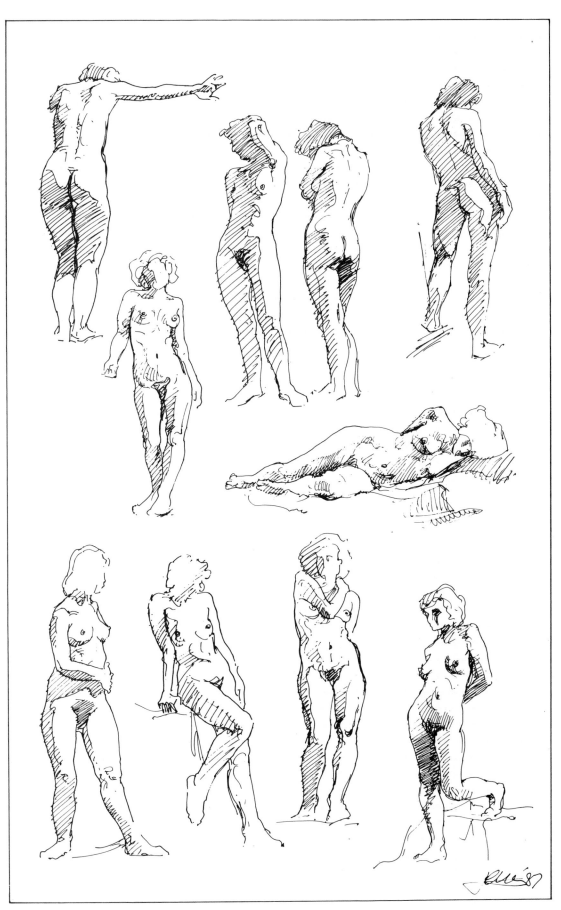

Deciding on a pose and knowing how to capture its rhythms is no easy task. In this, as in so many things, practice is the best teacher. Look at these ten sketches by Ferrón, drawn from nature in a single one-hour session.

Each sketch took an average of six minutes. On this occasion, Ferrón used a fine-nibbed felt tip pen, compelling himself to draw a clean line without possibility of alteration. To produce sketches like these, which synthesize form and pose with confident strokes and a perfect rendering of the shaded areas, is only possible after going through vast quantities of paper. Ferrón's example is a goal toward which you can work. Try to imitate his work and do not get despondent at some initial failures. Find some cheap paper and be prepared to use up a lot of felt tip pens. Do not go for perfection, but rather for spontaneity of line—even if your first efforts are not particularly accurate. It takes a good deal of perseverance to master figure drawing.

Contrapposto

The classic pose for human figure drawing is based on the Renaissance principle of *contrapposto*, in which the whole weight of the trunk is supported by one leg, while the other leg remains relaxed. Irrespective of the posture adopted by the arms and head, there will be *contrapposto*, a pose in which the following points may be noted: The hip of the leg on which the weight is carried is higher than the other; the shoulders and chest slope in the opposite direction.

Contrapposto also brings about certain differences in the appearance of each hip. These can be seen in the illustrations on this page.

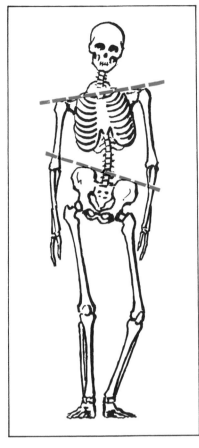

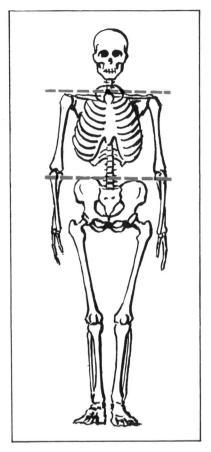

Above. In contrapposto the axis of the sacrum tilts towards the leg that is rigid; the pelvis tips up on this side and the shoulders slope in the opposite direction, causing the spine to curve.

Right. Look at the profile of the hips seen from the front. The iliac crest bulges outward (a), followed by a hollow (b) and another bulge (c) for the trochanter of the thigh bone. Notice that on the side of the relaxed leg, the hollow disappears (b) and the trochanter is marked by an indentation (d) rather than a protuberance.

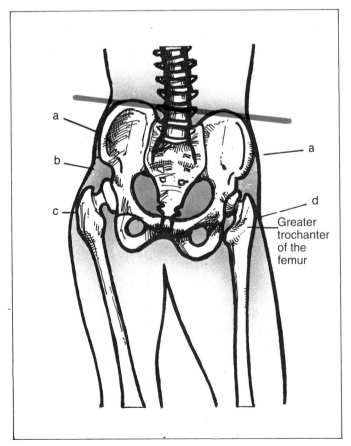

Greater trochanter of the femur

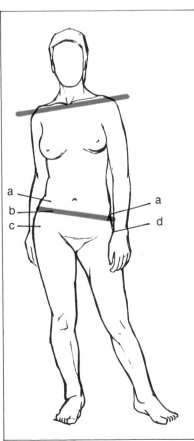

Sketch of a figure in contrapposto

Here are the three stages of a sketch carried out by Juan Sabater. Note (1) that when the figure is in *contrapposto* a vertical line drawn down from the chin passes through the heel of the supporting leg. This is important to remember when making any sketch in *contrapposto*. The second stage shows the figure with all its contours and also indicates where the shadows will fall. Sabater finishes his sketch by applying some basic tone which is enough to lend character to this lively and spontaneous little drawing. This sketch was drawn on fine-textured Canson watercolor paper.

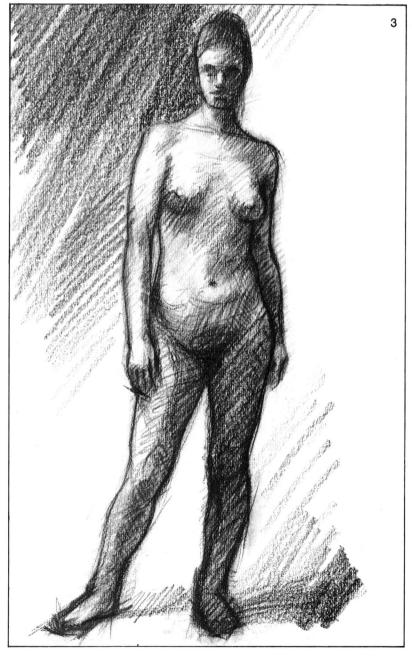

Female nude

When preparing to make a nude painting or drawing from life, it is important that the artist communicate to the model the concept of the work about to be produced. This is why Ferrón chats with his model before beginning a sitting: He shows her a few sketches of his ideas and discusses the pose she is to adopt and how long the sitting will be. In this case, it will be a normal session—about one hour.

1. Sketch of the pose
With the model posed, producing the initial sketch can begin. Ferrón has used light charcoal strokes that can be erased easily if necessary.

2. Initial color
Ferrón has blocked in the overall color of his picture using Eberhard pastels from Faber, which are almost as hard as chalks. Notice how from the beginning the color scheme is established: A cool background throws into a relief the warm tones of the figure, which is described through large areas of light and shade.

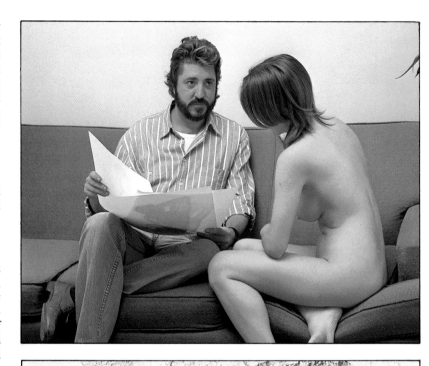

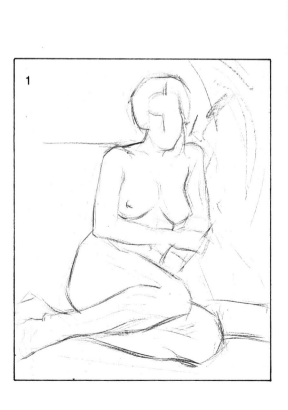

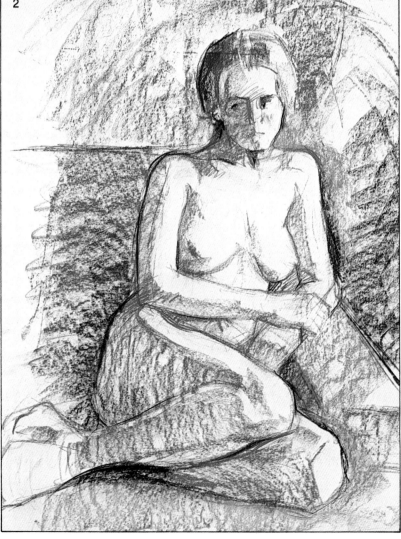

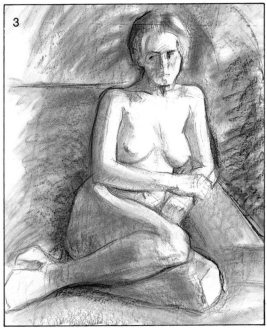

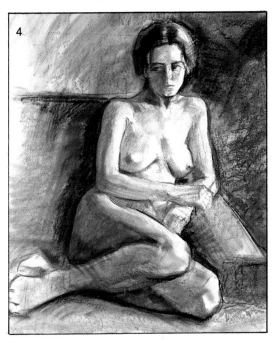

Third and fourth stages of the process, during which the author's vision of his creation has progressed from a drawing to a pictorial image. Having achieved a satisfactory image through the uninhibited use of line, he moves to the next stage where color becomes the focal point of the picture.

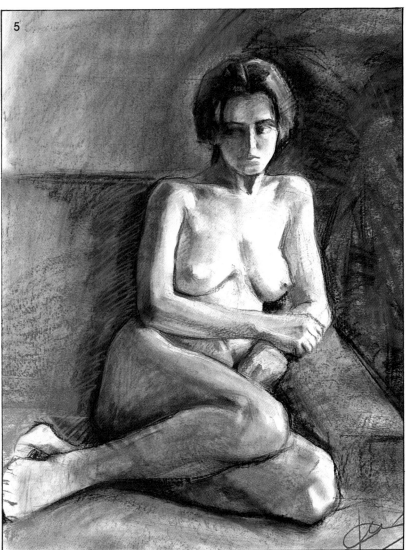

3. Initial blending of color

Ferrón used his fingers to blend the first layer of color, controlling the density of pigment and establishing contrasts. The first cool tones are applied to the figure using blue and black.

4. Building up color and depth

Darker colors are introduced, both in the background and on the figure itself. The form of the body has taken on depth through successive applications of tones and colors.

5. Final touches

The last stage of the picture. The artist's fingers have continued to blend the pigment on the figure in the picture, while the contours have been kept sharp through the use of line and contrast, giving the figure a luminous quality. An eraser has also been used to open up areas of white and to highlight the most illuminated parts of the subject. Light, energy, and personality are the particular virtues of this color drawing, which could easily be described as a painting.

Drawing with pastels

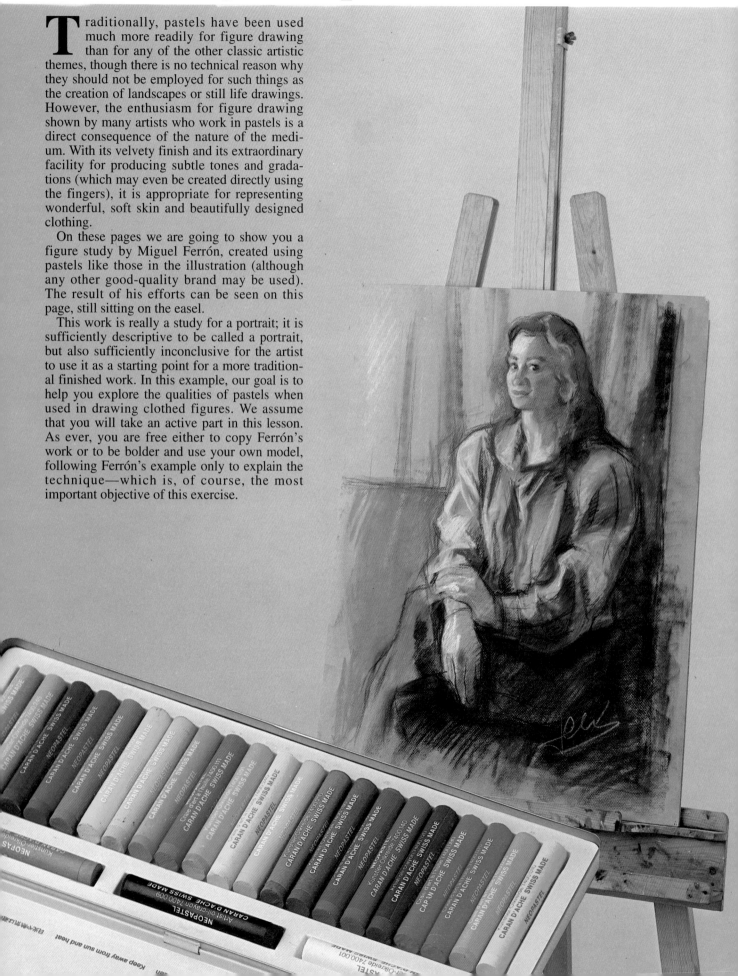

Traditionally, pastels have been used much more readily for figure drawing than for any of the other classic artistic themes, though there is no technical reason why they should not be employed for such things as the creation of landscapes or still life drawings. However, the enthusiasm for figure drawing shown by many artists who work in pastels is a direct consequence of the nature of the medium. With its velvety finish and its extraordinary facility for producing subtle tones and gradations (which may even be created directly using the fingers), it is appropriate for representing wonderful, soft skin and beautifully designed clothing.

On these pages we are going to show you a figure study by Miguel Ferrón, created using pastels like those in the illustration (although any other good-quality brand may be used). The result of his efforts can be seen on this page, still sitting on the easel.

This work is really a study for a portrait; it is sufficiently descriptive to be called a portrait, but also sufficiently inconclusive for the artist to use it as a starting point for a more traditional finished work. In this example, our goal is to help you explore the qualities of pastels when used in drawing clothed figures. We assume that you will take an active part in this lesson. As ever, you are free either to copy Ferrón's work or to be bolder and use your own model, following Ferrón's example only to explain the technique—which is, of course, the most important objective of this exercise.

Three examples from masters of the medium

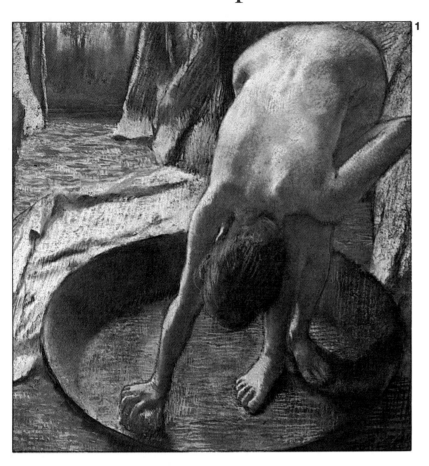

1

On this page we have reproduced three examples of pastel drawings of the human figure that are undoubtedly supreme works in this genre. Looking at these pictures you can see that pastel is a pictorial medium and not just for drawing. If certain works do not have the same build-up of color and are described as drawings, then one should study the results obtained by great masters of the medium to assess the pictorial qualities this technique can produce.

1. "The bather." An extraordinary pastel painting signed by Degas about 1886. This is an exceptional work, as much for its technical skill as for its originality of composition, which gives the picture an intense dynamism through rhythm and light.

2. "Portrait of Miss Laverque," by Jean-Etienne Liotard (1702–1789), in which the delicate colors and soft gradations lend a feeling of intimacy to the picture and give the figure its pleasant look of youthfulness and innocence. It has an atmosphere of carefully chosen warm tones.

2

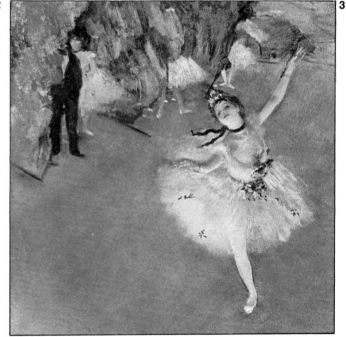

3

3. "The star." Ballet scene drawn in pastel by Degas, a work in which the rich superimposition of color created the delicate transparency of the lace costume of the ballerina.

■ Study for a portrait

1. Initial decisions

Once the artist knows who the model will be, then the artist must make two preliminary decisions: Which pose the model will adopt and which paper will be used. In the first case, it is a question of finding the most appropriate pose for that particular model. With regard to paper, it is a matter of knowing how to choose the texture and color best suited to the vision (mainly of the color scheme) each artist has before starting to work. Experience will have taught the artist that a work of art originates from the image the artist forms in his or her mind.

Look at the model who posed for Ferrón, her clothing and the surrounding atmosphere, and you will see why he chose a paper from the warm range of colors. The artist decided on a dark beige, medium-textured Canson watercolor paper.

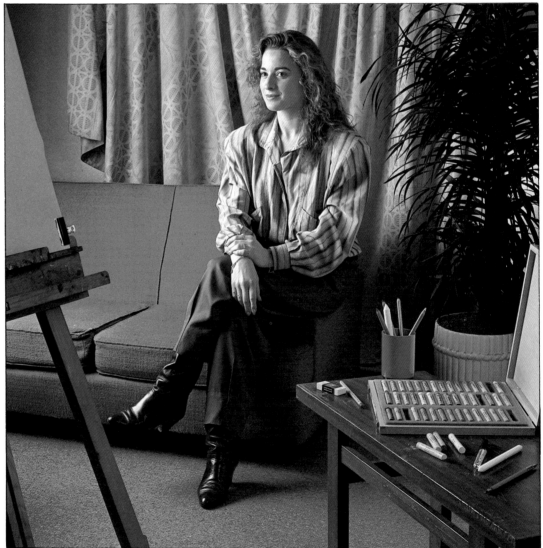

Above. Sample of papers in the warm color range. They are medium-textured Canson watercolor papers sold in sheets of 19¹/₂ × 27¹/₂ in. (50 × 70 cm).

Right. Here is the model posing for the artist; his viewpoint is that of the camera. Notice that the figure, like everything surrounding her, is bathed in warm light. This warmth is clear in the skin and the clothing but also, although to a lesser extent, in the tones that modify the green of the sofa and the curtain in the background. Far from creating a strong contrast to the model, they are in harmony with her.

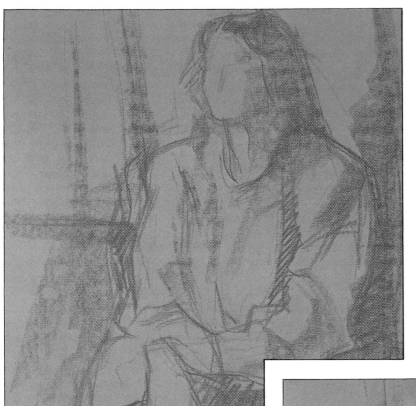

2. Initial sketch and adjusting the drawing

The initial sketch (left), in which Ferrón established the layout of the picture, was drawn with a burnt sienna pastel. Note how even in these early stages the artist considers form and depth in the drawing, immediately locating the most significant areas of shadow. From this point, Ferrón adjusts the drawing, defining different areas with lines and patches of Prussian blue that contrast with the pale violet highlights of the blouse and the whites and yellowish tones of the skin. The skin tones are subtly enhanced by touches of burnt sienna and orange.

Below is a photograph of Ferrón's work after the second stage. As you can see, while adjusting the initial sketch, the artist was also laying down a first layer of color using strokes that reinforced the drawing at the same time.

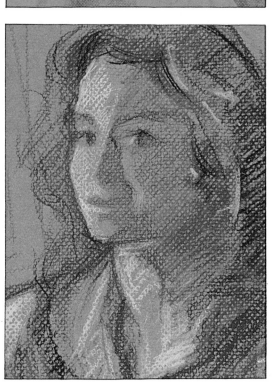

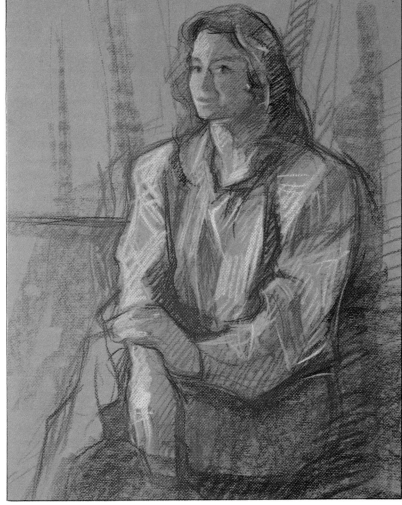

3. Building up color

Through these six close-up photographs you can see how the artist builds up the color in each part of the picture.

A. *Light, shade and half tone on the face and in the hair are created using violet, yellow, orange, and burnt sienna.*

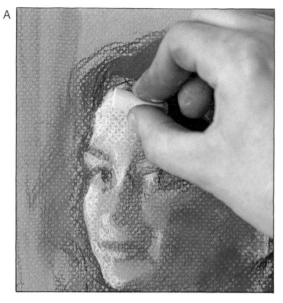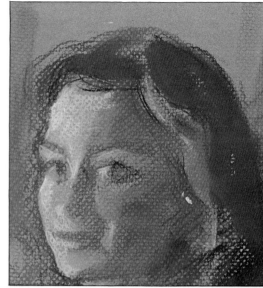

B. *Sutble tints in the hair, using Prussian blue for the darkest tones and burnt sienna for areas of half tone.*

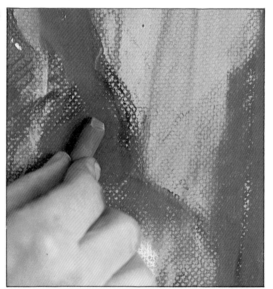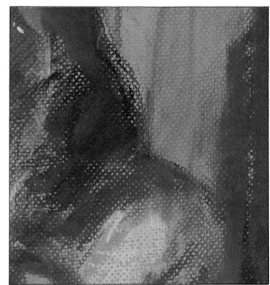

C. *Highlights and reflected light on the blouse, using firm strokes of pale violet to contrast with the shadowy background color of burnt sienna and the blue outlines.*

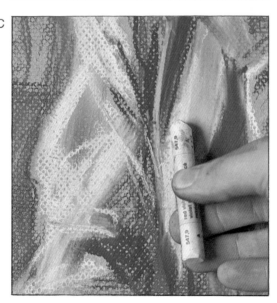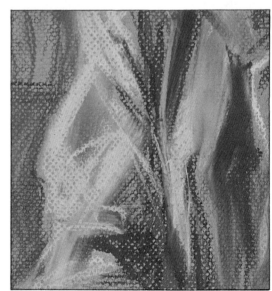

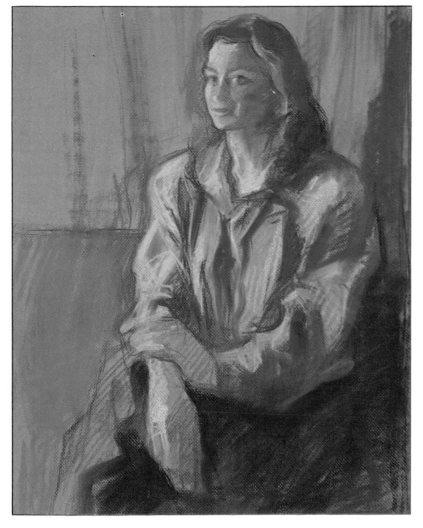

Do not confuse blending with gradating color. Gradation implies fading out or darkening of a single color, whereas blending involves mixing two or more adjacent areas of different color.

Left. Ferrón's picture after the basic color has been applied. At this stage, each color has been given its place in the picture. The artist has carefully considered its precise tone and location.

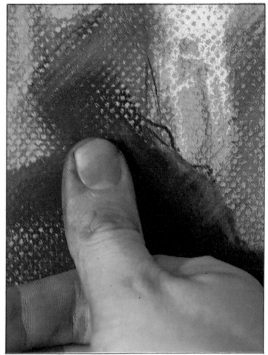

4. Blending of color

When you work in pastels, even though your intention may be to produce a simple study, it is hard not to blend pigment given the wonderful results it produces. In the three close-up pictures on this page, you see a few more areas in which adjacent colors have been blended with the fingers.

5. The final touches

On the right you see Ferrón's work after the blending stage, an indispensable step in achieving the velvet-like finish of some areas of the composition.

At this point it is time to put in the final touches of detail, light, and form wherever the skill and instinct of the artist deem them necessary.

Look at the two close-ups at the bottom of this page showing the left eye and part of the hair, in which the outline of the eye has been defined and the pupil built up (black pastel pencil). A few wisps of gold have been added on top of the dark mass of hair (yellow pencil).

You should also note that the blending of pigment has not been overworked; the color has not been forced too deeply into the texture of the paper so a shimmering effect is maintained.

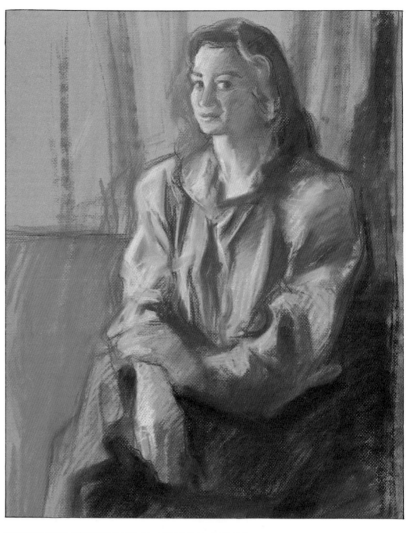

Below. *Two close-ups showing the texture and color of the paper. Don't overlook the little splash of green on the eyelid that lightens it up.*

Right. *"Study for a portrait," by Miguel Ferrón. Normally, a study implies a piece of work that is more than a sketch, but not as elaborately worked as a finished picture.*

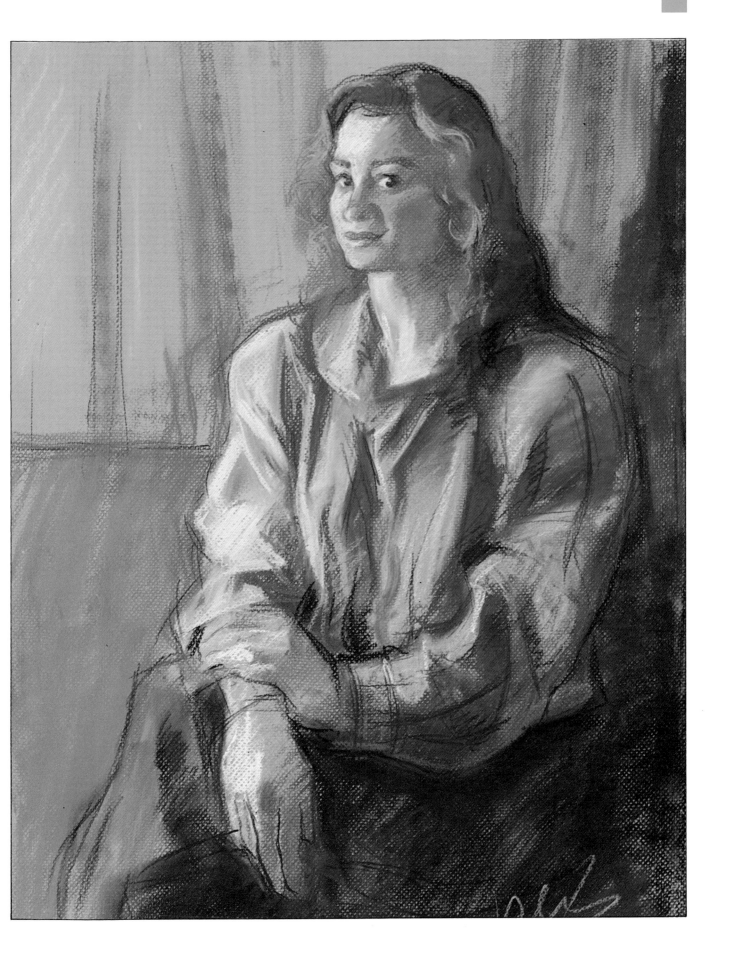

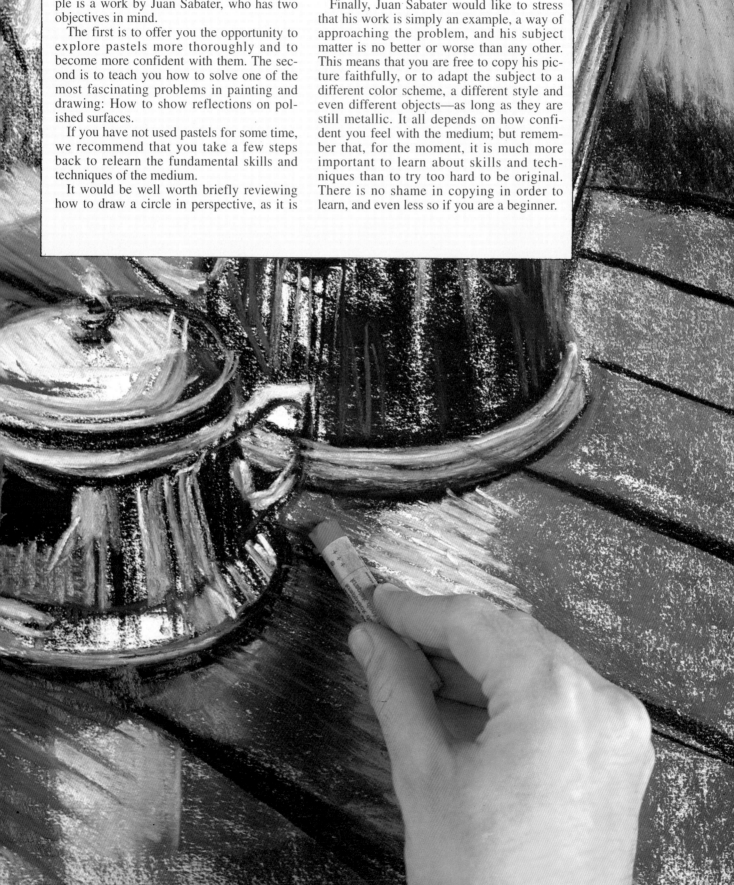

The exercise we have set for you here is to produce a still life using pastels. Our example is a work by Juan Sabater, who has two objectives in mind.

The first is to offer you the opportunity to explore pastels more thoroughly and to become more confident with them. The second is to teach you how to solve one of the most fascinating problems in painting and drawing: How to show reflections on polished surfaces.

If you have not used pastels for some time, we recommend that you take a few steps back to relearn the fundamental skills and techniques of the medium.

It would be well worth briefly reviewing how to draw a circle in perspective, as it is an essential element in the exercise we created for you.

Finally, Juan Sabater would like to stress that his work is simply an example, a way of approaching the problem, and his subject matter is no better or worse than any other. This means that you are free to copy his picture faithfully, or to adapt the subject to a different color scheme, a different style and even different objects—as long as they are still metallic. It all depends on how confident you feel with the medium; but remember that, for the moment, it is much more important to learn about skills and techniques than to try too hard to be original. There is no shame in copying in order to learn, and even less so if you are a beginner.

Three examples by Ferrón

Before starting on your own picture, study these little drawings by Miguel Ferrón, which are good examples of his personal style with pastels. He prefers to leave the contrasting colors just as they appear directly after being applied, but does not sacrifice the technique of blending color, which he uses primarily where there is a thick layer of color.

Notice the unusual way in which the different areas of color barely describe the objects. They merely offer an impression of form, the main outlines being defined by black lines strategically situated in the composition after the principal colors have established the basic shapes and tonal and chromatic contrasts.

Equipment

Sabater used the materials shown in the picture on the right:

- Soft pastels (manufactured by Rembrandt).
- Charcoal.
- A torchon.
- A putty eraser.
- A sheet of medium-textured Canson watercolor paper about 13¹/₂ × 19¹/₂ in. (35 × 50 cm).
- Drawing board with clips; a rag or absorbent paper.

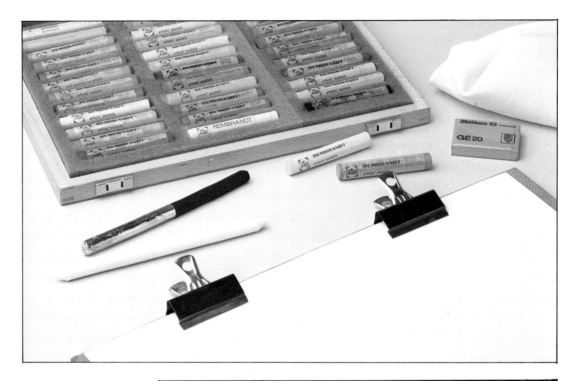

The subject

Here is a photograph of the arrangement Sabater chose to paint from life. In spite of the differences of color that result from a photograph (colors always seem deeper than in real life), it represents a sufficiently good guide on which to base the picture. It is clear that the pictorial interest of this still life lies in the sharp reflections produced by the metallic surfaces. We feel that this particular quality of the subject justifies titling the work "reflections on metal objects." However, from the artist's viewpoint, the reflections are not a separate entity, but rather incidental chromatic effects, sometimes very striking, that fall within a consistent overall color scheme.

Look at the subject: Can you define a clear tendency toward one color range? Would you go for a warm or cool range? Sabater will offer his solution, but you may have one of your own.

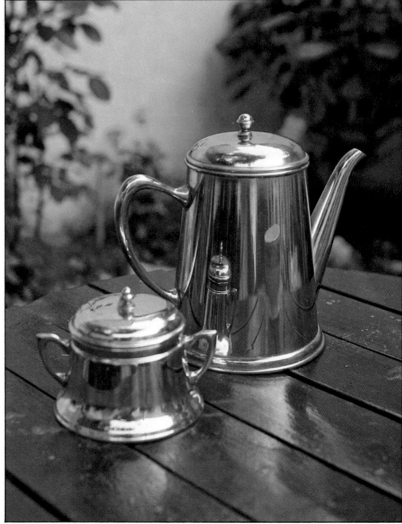

Against a cool, blurred background, the warmer foreground stands out clearly, and, against both of them, the metallic surfaces with their cold highlights and the reflections of the warm colors of the wood have a powerful impact.

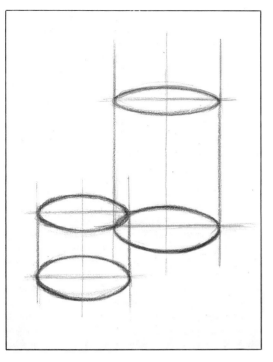

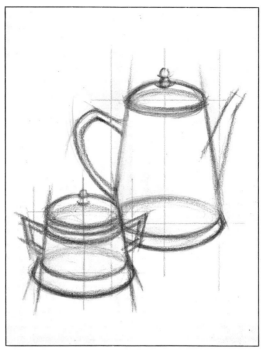

Preliminary studies

Although it is not essential (Sabater has not done it himself), we suggest that you carry out a preliminary study of the layout and perspective of the two stainless steel objects that make up the theme of our still life.

With a lead pencil (a 2B, for instance), establish the shape of the objects, starting with two cylinders. Study the layout, paying attention to the question of perspective.

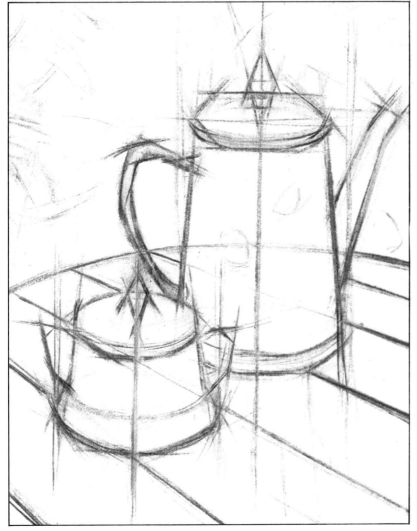

The definitive sketch

Whether or not you have done any preliminary studies, the next step is to draw a definitive sketch of your subject. You can do this in charcoal or, if you prefer, with a stick of sepia-colored chalk, applying strokes that define the general shapes of the objects. Look at Sabater's sketch; you can see the guide lines on which he based this first stage: The vertical axes, lines of perspective, and so on. When you are happy with your sketch, take a rag and brush the lines away, so that the definitive shapes can then be laid in on top of the traces of the sketch, as shown in the photograph below.

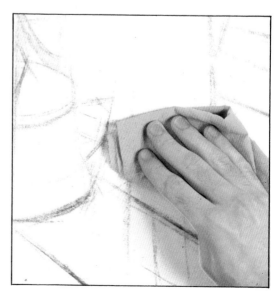

The definitive drawing

In this second stage, the artist firmly and accurately establishes the forms, definitively outlining the objects and the surface of the table. Sabater does not want to have to modify his drawing once he is working in color. He prefers to dedicate as much time as necessary to producing in charcoal a linear representation of the subject. On top of this he can then apply color while remaining absolutely faithful to the outlines, which, from this point on, should be regarded as sacrosanct. It is not a waste of time to linger over this stage—quite the reverse. The time you take now will pay dividends later when you find that you can apply color without having to rectify mistakes along the way. All you will have to worry about is preserving the original drawing, which is a very different exercise.

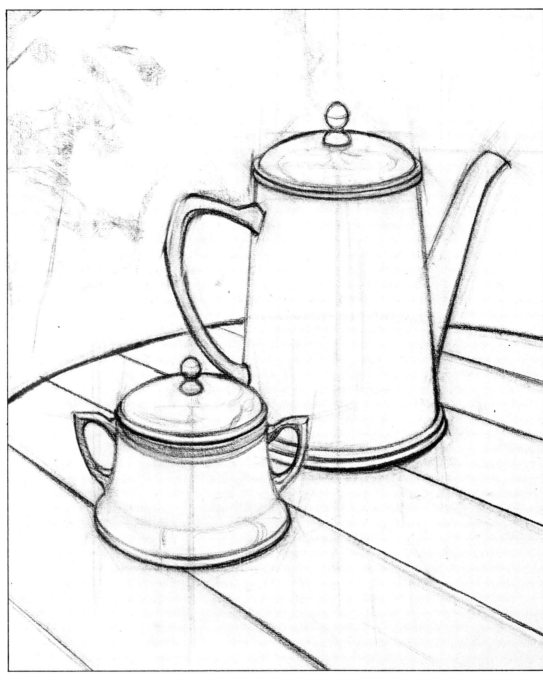

Right. Close-up details of some of the circles in the drawing. Don't forget to apply the rules of perspective. Remember that, when drawing a cylinder, the intersection of the curve of its base and its vertical sides should be a continuous line.

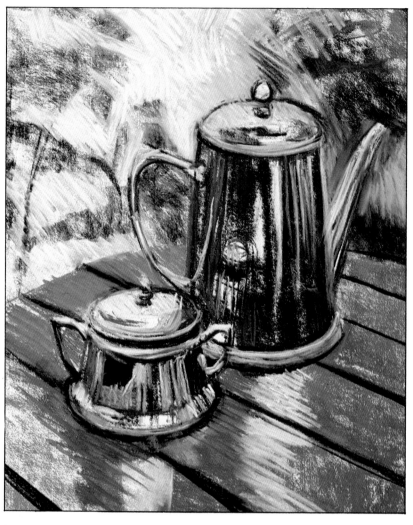

Setting the tone

It is clear that when starting his picture, Sabater did not opt for a specific color scheme. In the early stages of his work, there is no marked tendency towards any particular range. More apparent is his intention to divide the composition into two opposing halves: A cool background and the warmer colors of the receding plane of the table.

For the moment the metallic objects have been given very little color. Sabater's main objective was to place the white reflections in contrast to the larger black areas. The chromatic harmony between the two objects and the colors surrounding them is hinted at with touches of violet (similar to the cold background color) and other touches of brown (like the warm colors of the table surface). Now it is your turn. Follow Sabater's methods, but without worrying too much about reproducing the colors exactly. You can certainly try to stay within the same range, but let yourself be guided by your own ideas.

At this stage, work exclusively with the pastels, rubbing them against the paper but without penetrating too deeply into the grain.

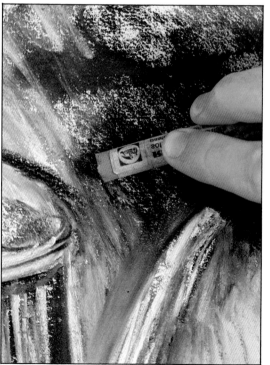
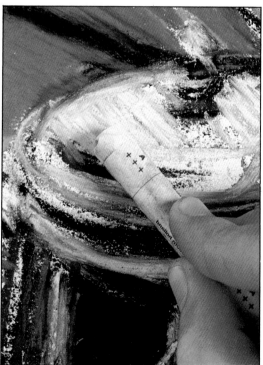

Left. Close-ups showing cool colors being applied in two contrasting areas of the picture: Green in the background and a pale violet on the metal surface. Observe how the artist has worked: He has used individual, separate strokes, intending to create an initial vision of the colors that may dominate the picture and of their distribution throughout the composition.

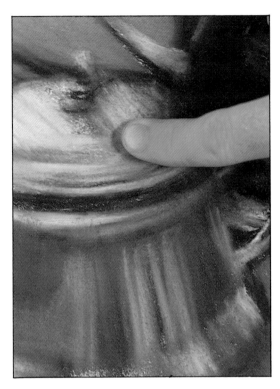

Right. Close-ups showing the velvety effect created with pastels after having been engrained in the texture of the paper with the fingertips. Compare these close-ups with those on the previous page and you will see the difference between the fragmented color applied by the pastel sticks and the unified color spread across the surface of the paper with the fingertips. In the latter, any unevenness of color has disappeared.

Color blending and final stage

With your fingertips (Sabater prefers to use his thumb and index finger), blend the pigment in all parts of the picture. Remember to either change the finger used each time you start working on a different color or to clean it first with a cloth. The goal is to blend colors that until now have appeared rather fragmented, but not to mix them together. Blur the harsher lines so that the different surfaces take on that softness characteristic of pastel painting where the pigment is deeply engrained in the paper surface.

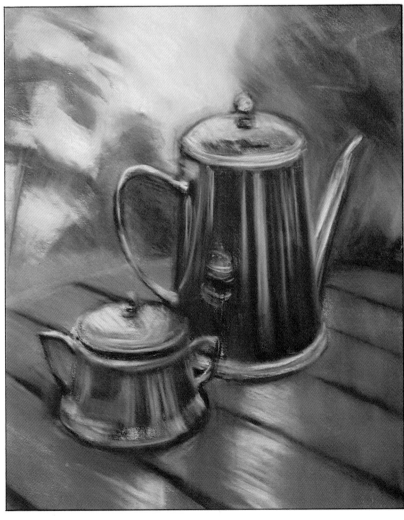

The blending process tends to flatten areas of contrast, so you will have to add some more color to these parts. On the right you see how Sabater's picture looks after the general blending process and then, on the opposite page, when it is finished.

So what did the final stage consist of, exactly?

Color was added to the blended pigment to achieve a more luminous background with more interesting contrasts; the presence of three little patches of pink are enough to suggest the presence of flowers that strike a warm note in an extremely cold part of the picture.

The teapot and sugar bowl have been brought into harmony with the foreground through the warm colors in the reflections and with the background light (seen on the metal surfaces) through the introduction of blues and blacks.

A few touches of ochre, blue and white have brightened up the wooden table surface. To sum up, then, we have a warm foreground (containing the metal objects) and a background dominated by colder tones.

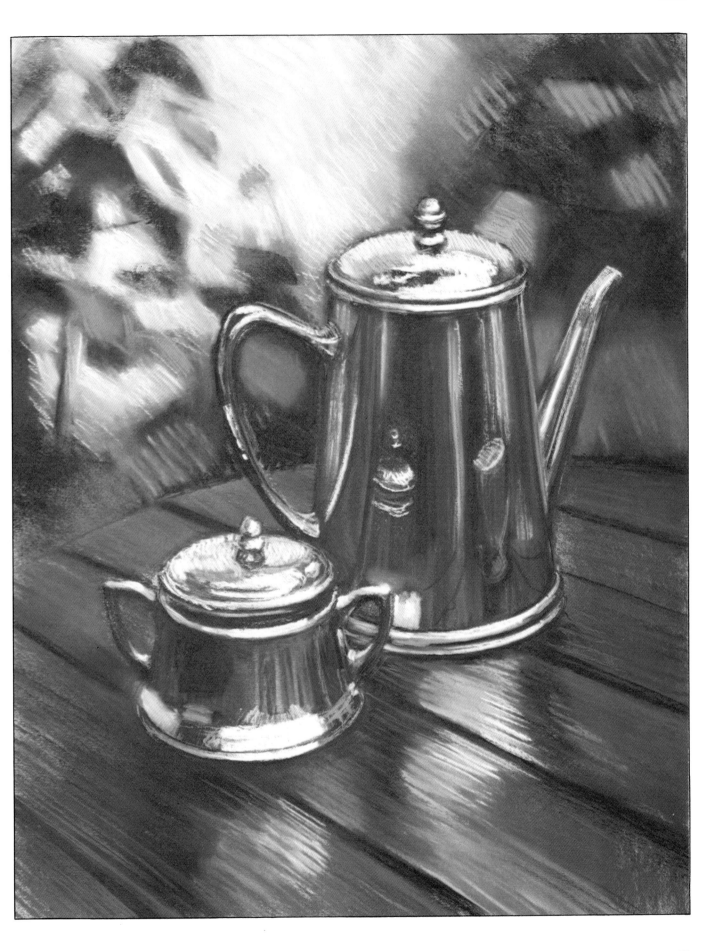

Portrait of a little girl, based on a photograph

Pastel colors can be adapted to virtually any subject. Through what you have read—and your own experiments—you will have discovered the versatility of the medium. For instance, in the previous exercise showing the development of a still life that offered a variety of tonal and chromatic contrasts.

However, pastels seem to lend themselves especially well to subjects that, because of some intrinsic quality, require soft colors and careful gradations—the portrait is a good example. In this next practical demonstration, you will be able to follow the creation of a pastel portrait painted by our good friend, Juan Sabater. Using few words (the artist is happier expressing himself through line and color), he will describe the different stages, starting with the photograph he took of the model and ending with the finished pastel work you see on this page, still resting on the easel.

Pastel portrait by Juan Sabater, and a box of pastels of the Rembrandt brand, showing the warm and cool ranges used by the artist.

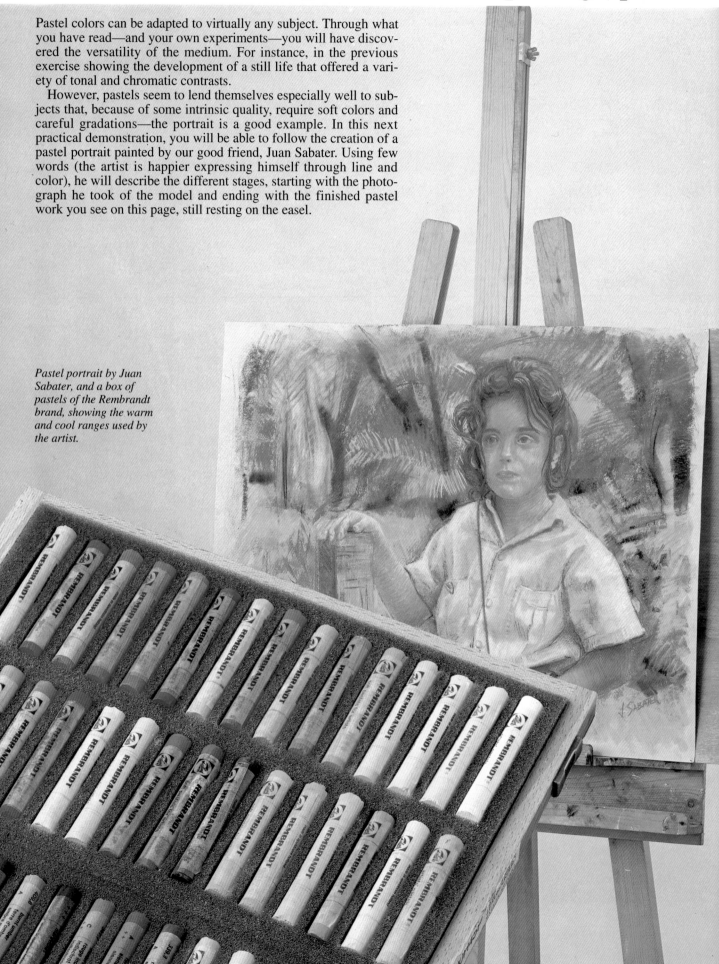

Four examples from masters of the genre

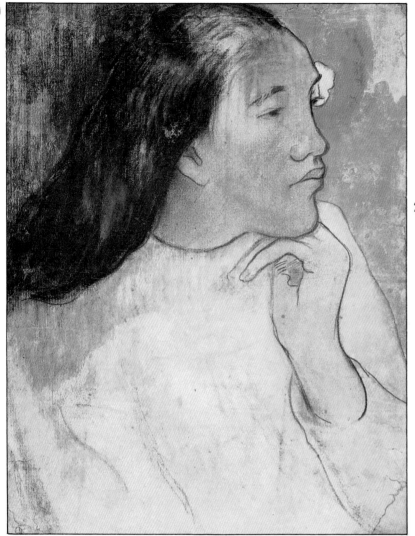

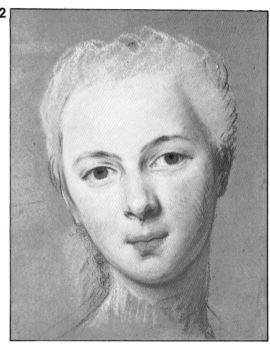

1. "Tahitian woman," by Paul Gauguin. Pastel drawing with touches of amber (a yellowish resin), Metropolitan Museum of Art, New York. In this work, Gauguin used pastel in an unconventional way, simply to illuminate a line drawing.

2. "Mademoiselle Puvique," by Maurice Quentin de la Tour. This great pastels specialist showed his mastery of the medium in this portrait, which could be described as a drawing or a painting; pastels are equally capable of producing either.

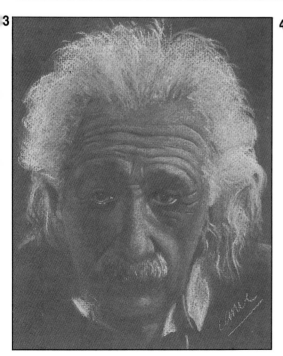

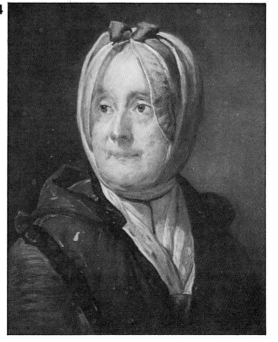

3. "Einstein," by Carmen Pairés. Chiaroscuro portrait, using white and burnt sienna pastels, on a dark paper with a greenish tint.

4. "Portrait," by Jean Baptiste Siméon Chardin. This is a portrait of the artist's wife in which pastels were applied with the intention of producing a completely pictorial result and cover the paper completely. They create a richness of color worthy of the most extensive palette.

The model

"This exercise consists of creating a pastel portrait of this wonderful little girl with her wistful expression, using the same pose and surroundings as those captured by the photograph. Because I like the pose, and because the object of this exercise is to elevate a photographic subject to the status of a pictorial work, I will remain true to the photograph while interpreting it in a lively drawing style (not at all photographic). I will try to avoid falling into the trap of producing a photograph of a photograph."

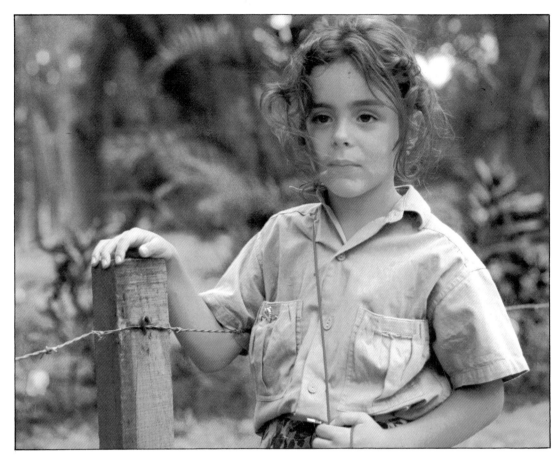

Preliminary study

"To get to know the subject, I made a preliminary charcoal study in which I tried to capture the basic expression and the main areas of light and shade. In my initial study, you will notice that the whole of the left hand appears. Logically, at this stage any obvious defects of the photograph can be corrected. However, for me the most important concern in this first study was getting the face right—capturing the features and the child's expression. I think I have managed to do this."

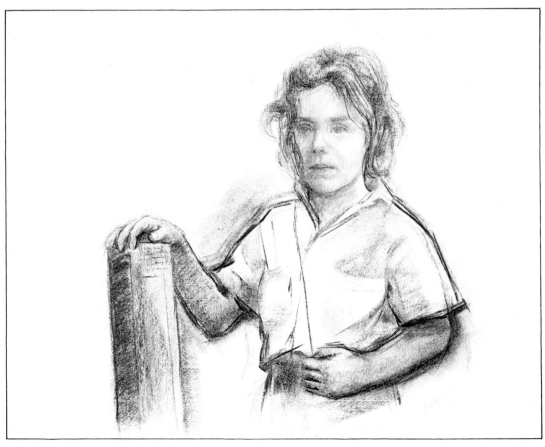

Initial sketch

"Now that I have decided what I am going to do, I have taken a sheet of light gray Canson watercolor paper, about $19^1/_2 \times 27^1/_2$ in. (50 × 70 cm). The color of the paper is similar to the color of the model's shirt, a subject that takes up quite a lot of the picture. Because I want to create a picture with soft tones and contrasts, I have decided to work on the reverse side of the paper, which has a smoother texture than the front. Using my preliminary study as a guide, I made an initial sketch of the figure that stands out against the green, blue and sepia touches of the background."

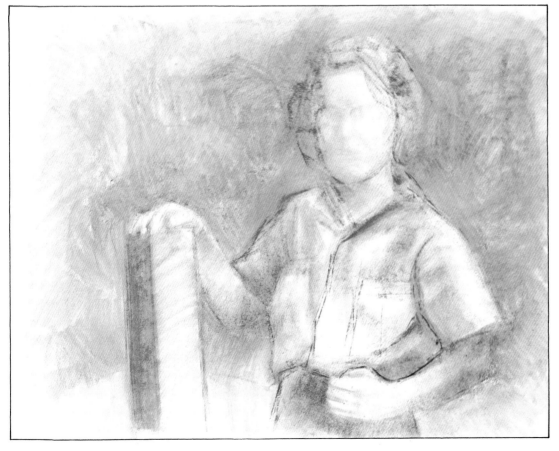

First color blending

"Using my fingertips and a torchon, I blended the greens, blues, and sepias that have been applied to the sketch. I began to describe the form of the figure, indicating the main areas of light and shade through a base of sepia. At the same time, I tried to establish the cool-warm contrast central to the theme. The warm flesh color stands out against the cold background, while the more neutral color of the shirt helps to tone down what might otherwise have been too strong a contrast."

Building up color

"The moment has come to start applying color to determine the general tonal range of each part of the picture. For the time being, I will work with pastels applied directly to the paper surface without worrying about the inevitable irregularity of these areas of color.

"I take care to ensure that each color area is correctly located. This is to avoid the risk of blurring the initial sketch, an occurrence that would mean all my earlier work had been wasted."

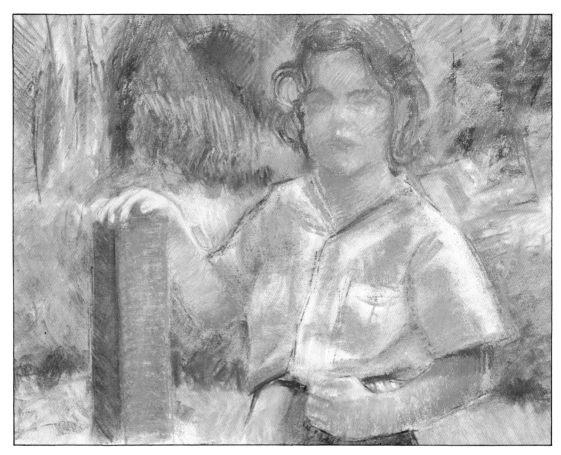

Second color blending

"Without getting too involved with detail, I use my fingertips and the torchon to produce a softer finish and, at the same time, work on harmonizing color in the picture. In particular, I try to set the tone for the definitive color values to be established by adding and blending together new layers of pigment."

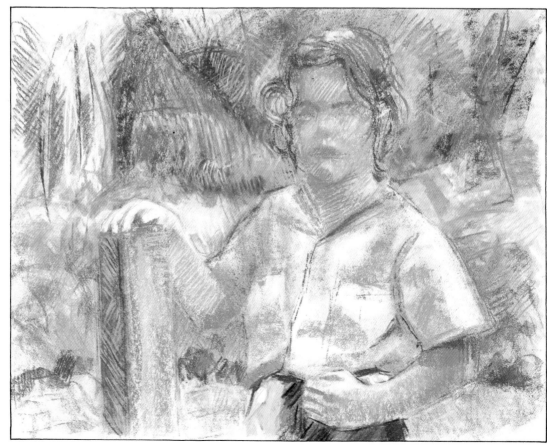

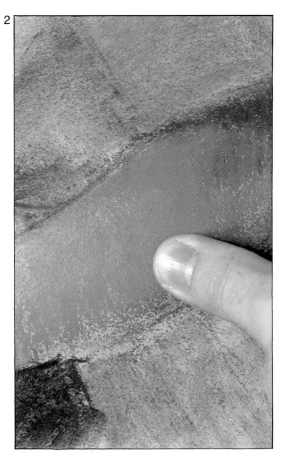

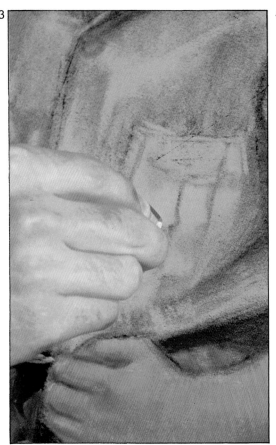

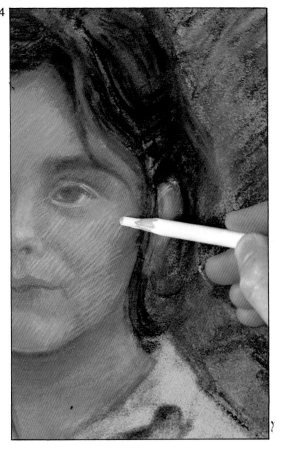

Close-ups

"Here are four close-ups showing details of what might be termed the beginning of the final stage of my picture."

1. Left arm after the color has been applied, before blending.

2. The same area after it has been blended with the fingertips. Look at the change in color (it becomes more luminous) and texture that occurs when the pigment is completely embedded in the grain of the paper.

3. Part of the shirt after being worked with a sepia pastel stick, the color being first applied and then blended.

4. Half of the face showing a uniform background color, deeply ingrained in the paper surface. A layer of dark sepia and then a white pencil have been superimposed to describe the features and the contours.

The final stage

"On the right you can see my finished work. At least, it is finished according to my criteria. As you have already seen, I don't like pictures that are too finished. However, I do feel that everything relating to form, expression (when working on a portrait), and harmony of color should be carefully studied and correctly applied. If these criteria have not been met, I never consider a picture properly finished. Take a look at what I have done to complete this particular picture.

"Notice the richer tones of the background, achieved through the application of superimposed strokes of intense color; also, the greater softness of the whole figure, created through further applications of pastel color and blending with the fingertips. Observe how I harmonized the picture as a whole by giving the background more warmth, thus bringing it closer in color temperature to the dominant figure in the foreground. The tinges of violet added to the background greens also appear, although very discreetly, in the little girl's hair and act as a counterpoint to their complementary color. The yellows and earth colors lose some of their excessive dominance as a result."

Below. Close-up of the girl's shirt in which you can see the fixed color of the paper through the color applied on top.

Right. Portrait of a little girl. A pastel painting by Juan Sabater, based on a photograph supplied by his client.

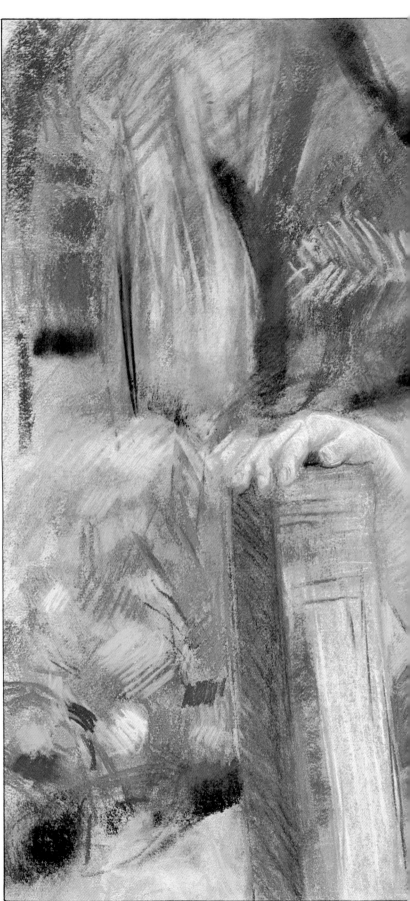

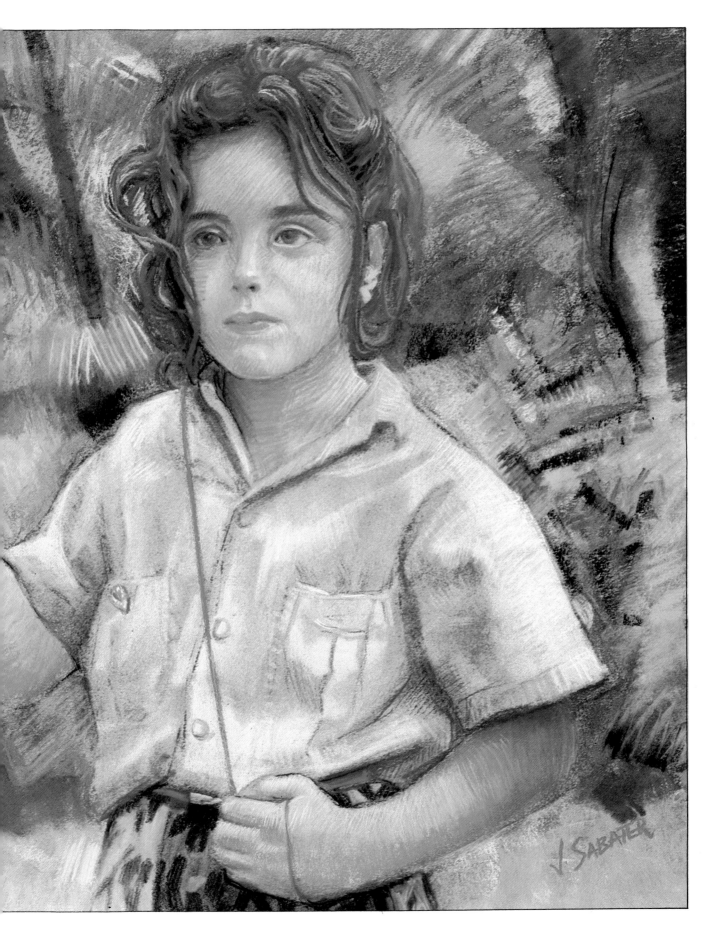

A floral subject in oil pastels

On this occasion, we will demonstrate the process of creating a picture on wooden board using oil pastels. Our guest artist, Ester Serra, has used Caran d'Ache pastels, but every artist has his or her preference and this does not mean that other makes are not equally suitable. All major manufacturers make oil pastels; choose the type you feel best suits your requirements.

With her inventive way of working, Ester Serra is a fairly unusual artist. She comes up with some wonderful textures and qualities in each medium, throwing a new light on visual expression.

Because this artist's style of work does not follow traditional, academic methods, it is best to let her explain for herself, step by step, what she does and why she does it.

Nobody would claim that the method outlined here is the best way to work with oil pastels. We do, however, hope that you will become accustomed to seeing, evaluating and experimenting with non-traditional ways of looking at painting. Remember that without breaking rules there cannot be progress. Painting always progresses little by little with the discovery of new aesthetic concepts and techniques.

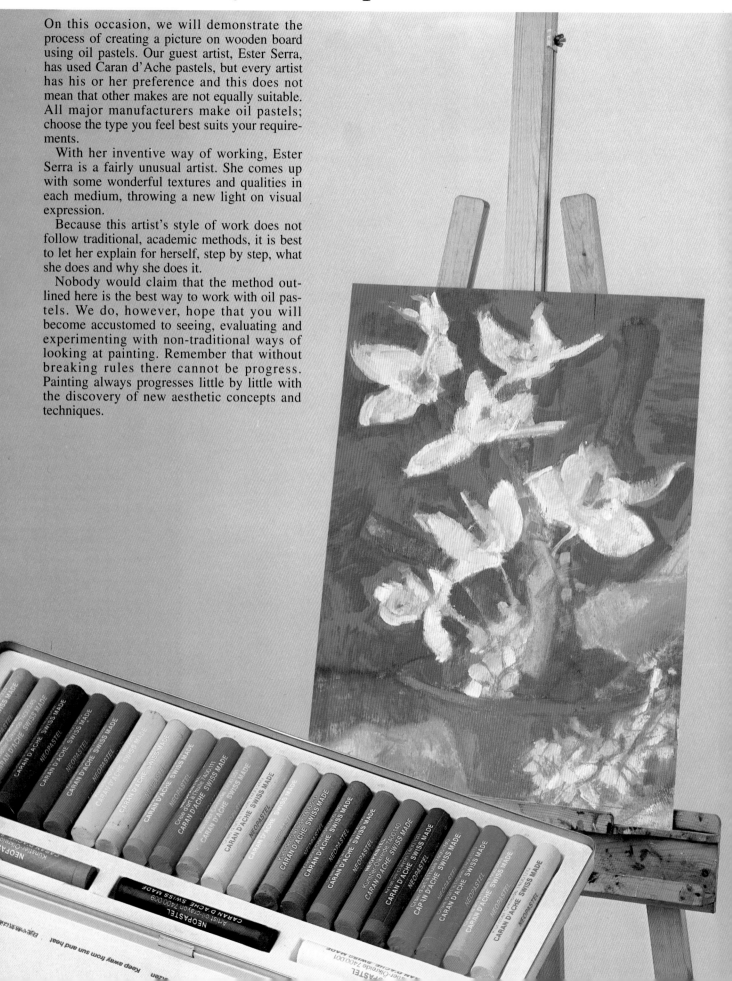

An interesting aspect of Ester Serra's example is her use of three different techniques for applying oil pastels within the same work.

The first of these is illustrated in **A** (left), in which color is simply applied with the stick, either in a thick layer of color or else revealing the texture of the paper. The second (illustration **B**) shows the classic blending method created with the fingertips: This method is always harder with oil pastels than with the more flexible soft pastels. In illustration **C**, you can see the third technique: Diluting the pigment with turpentine essence applied directly to the working surface.

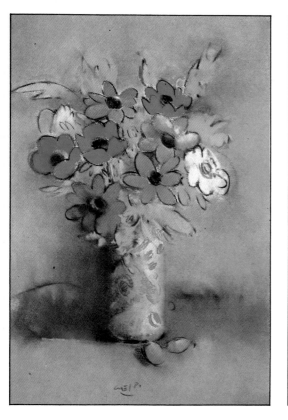

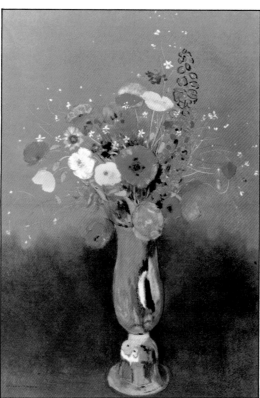

Two examples of floral themes created in pastels by the artists Francesc Crespo and Odilon Redon in which the most traditional methods have been used. You can compare this style of working with that of our practical example.

Preliminary studies

"Whenever I sit with a subject in front of me, I convince myself that what I see is just a starting point. Perhaps it would be more accurate to say that, for me, a subject is an excuse for painting; it is a sensation that gives rise to another sensation born out of my creativity. In this instance, I have before me a flower pot containing garden plants that are very tempting to copy or interpret in a natural way. Personally, I prefer to take what I consider to be the most characteristic element of my subject and, as I am working, to forget about the actual object and allow my ideas to take over. Before working on the wooden support I prepared, I made two preliminary studies as a warm-up exercise: One to establish the color scheme and the other tonal. This process stimulates my creative imagination and helps me get a preliminary mental image of what I am going to do.

"It is quite possible, however, that this image will change many times during the picture process. There is nothing like actually working on a picture to prompt the imagination. It is interesting to note how with each new creation one sees further creative possibilities or, in the case of preliminary studies, ways of defining ideas.

"At the bottom of the page, you can see the preliminary studies. I used oil pastels on Ingres paper instead of the board I will be using for the definitive picture."

Color study and tonal study for the picture to be painted. The artist worked in pastel directly on Ingres paper, rubbing the pigment with her fingertips and diluting it with turpentine essence. She tried to achieve chromatic equilibrium and reduced the range of colors to four basic ones: Yellow, violet, an iron oxide brown, and a cool gray, as well as white.

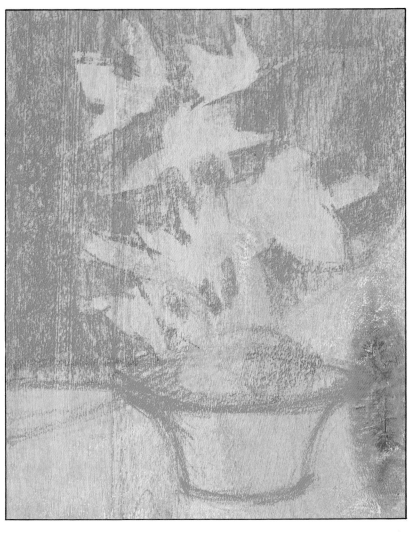

Step 1. The sketch

"I like using wood as a support for my pictures. It is a very warm material that is also tough enough to allow me to use a variety of techniques, whether or not they require an absorbent surface. You can apply very thick or very dilute color to wood: Watercolors, oils, acetone or nitrocellulose-based; you can scratch it, knock it about and even burn it. If you add to this the fact that the wood's color serves as a good base for subsequent washes of color, then you will have a complete list of the reasons for my personal preference for this support.

"In the sketch, guided by my preliminary studies, I distributed the elements of the composition, using pastel color applied directly to the support. At the same time as I am locating basic forms, my two earlier studies allow me to start hinting at tone and color, although it is just hinting at this stage.

"The colors are basically the same as those I used in the studies, the only difference being that I substituted the darker blue for the violet, which gives me a colder base. I am not the kind of person who plans the smallest details in advance. On the contrary, as I work ideas pop into my head that lead to different decisions. Now that I have opted for a blue background, I am considering the possibility of finding a compromise between this color and the violet I envisaged in the sketches."

Close-ups in which you can see two ways of applying pastel: Holding the stick flat to produce a fairly uniform mark, and then using the tip of the stick when a more linear stroke is required.

Step 2. Initial color

Ester Serra continues:

"Bear in mind that oil pastels dissolve in essence of turpentine. I feel this characteristic should not be ignored; it offers a new way of applying color as well as the possibility of working on the picture with a brush after the first application of color with the pastel stick. Until now I have not extended my range of colors, but rather have built up the existing ones in each area of the composition. In this second phase of the picture, essence of turpentine will allow me to intensify the color of the background while at the same time (because the pigment will become liquid) revealing the texture of the wooden support.

"The same brush I used to dilute the background color has also been useful for defining the forms of the flowers, which become more substantial in contrast with the stronger background.

"To create a chromatic contrast between the drapery surrounding the flower pot and the background, I added a tinge of violet to the area describing the cloth, applying the color directly in pastel. Although the drapery is dominated by warm tones in the real model, I prefer to harmonize this area with the background and to leave the warmer colors exclusively for the flowers. In this way, the flowers become the focal point of the picture, which seems appropriate when the flowers are the main attraction of the picture."

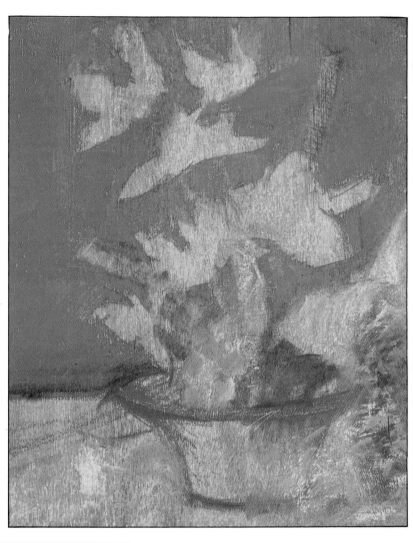

Right. In these two close-up photographs, you see the brush at work loaded with turpentine as well as with part of the picture surface, which shows the effect of diluting the pigment. Remember that the pigment was previously applied directly to the wooden surface with a pastel stick.

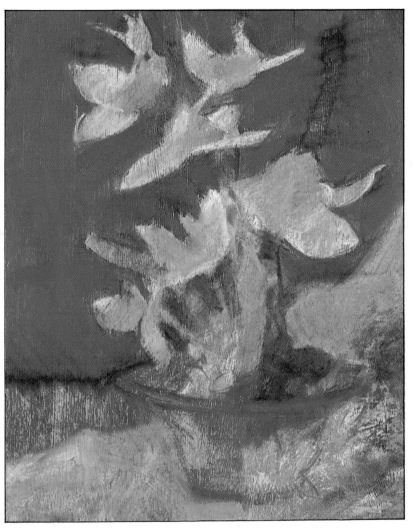

Step 3. Building up color and form

"Throughout this third stage of my picture, I paid equal attention to color and volume. I worked on the color and the internal structure of the flowers and, in general, tried to give the whole composition a greater sense of depth. I also worked on the drapery, blending the pigment with my fingertips (not with turpentine). In my pictures, I try to combine the various possibilities offered by the medium I am using, so the images I create tend to have two, three, or more different types of finish.

"In this floral theme you can see the variety of techniques used: In the flowers, the pastel sticks were used by themselves; the background color was blended using a brush and essence of turpentine; the drapery has been blended using the fingertips and, finally, the color and quality of the wood show through in an almost unaltered state in the flower pot and the table top. Notice that in these areas the color has hardly been altered because it seemed to me that the base color and the texture of the wood itself were perfectly appropriate.

"I must say that, although I am attracted by color and form, my aesthetic creations move toward an exploration of texture. I am more attracted to the intrinsic qualities of the material itself and this predilection inevitably shows through in my finished works."

Left. In the first of these two close-up illustrations, you can see my fingers working on the picture surface. Notice the effect achieved and how the color and texture of the wood show through the violet tones of the cloth. In the second close-up, touches of color applied directly with pastels on the flowers stand out against the more intense color of the background.

Step 4. The final touches

"I finished my picture by accentuating the form and depth of some elements by adding more pigment. In some areas I worked directly with pastels, and in others I used the paintbrush after diluting the color on a white china plate, as you see in the photograph below.

"I gave the background the violet tinge I initially indicated in my preliminary study, although I softened it with an earth color so that it is in harmony with the rest of the picture. I have still allowed the blue base to breathe through, however, creating an overall effect of vibrant color."

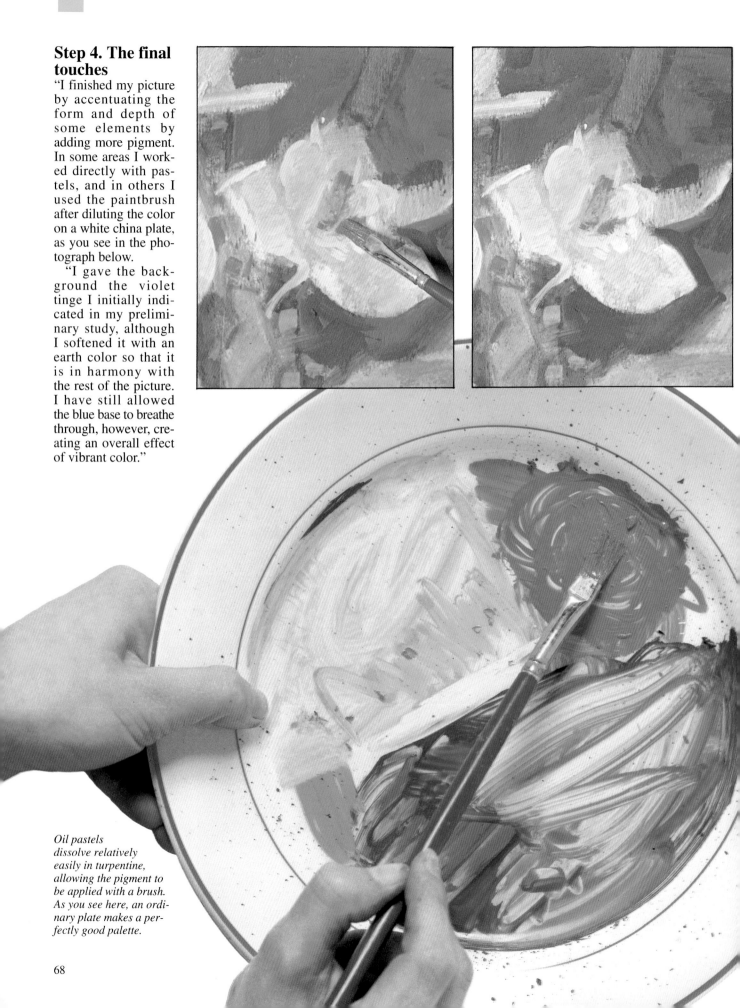

Oil pastels dissolve relatively easily in turpentine, allowing the pigment to be applied with a brush. As you see here, an ordinary plate makes a perfectly good palette.

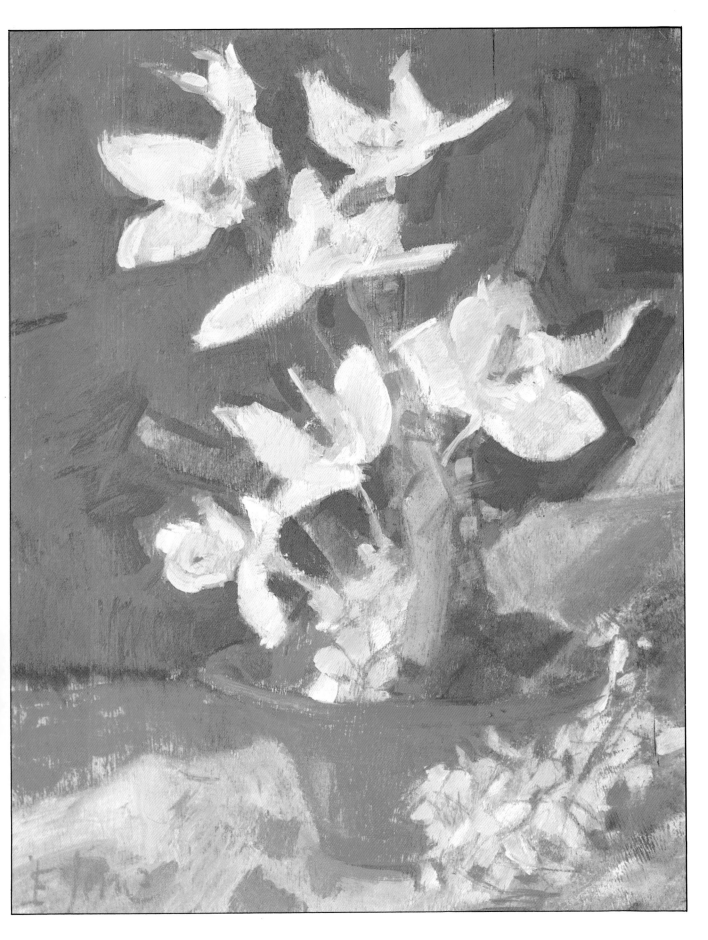

Wax crayons

The technique of using wax crayons is probably not new to you. As a medium, they are sometimes compared with oil pastels because of certain characteristics they have in common. You will find this out for yourself by following this step-by-step exercise, in which Ester Serra, who just gave us her personal interpretation of a floral theme in oil pastels, will explore a similar subject using wax crayons.

Let's take a look at the main characteristics of this medium:

• Crayons are applied directly to the support and may be blended (though only to a limited extent) using the fingertips, a torchon or a cloth.

• Wax crayon is very difficult to erase. The best method of removal is to scrape as much as you can from the surface and then to use a plastic eraser. However, some pigment will always remain.

• Wax crayons may be dissolved in turpentine essence. It is always best to work with the most refined product, although everyday materials will also give good results.

• Crayons are extremely opaque colors and may be superimposed.

• When you use a blade or pointed implement to scrape the surface of a superimposed color, the underlying color will appear. This feature offers a wide range of possibilities as far as texture is concerned.

• Normal fixative may be used on wax crayon drawings.

We will assume you are familiar with this information, and that you can now follow without difficulty the practical demonstration Ester Serra has drawn as an example.

Three examples from masters of the medium

Left. *Detail from a study by Miguel Ferrón, demonstrating in a single work most of the techniques of wax crayon drawing. The white areas have been reserved with masking fluid and the background has been painted with a brush, using wax crayon dissolved in turpentine. The carmines, greens, and yellows have been applied directly in wax crayon. You can see that, after the masking fluid was removed, new shades (basically blue and green) were introduced using a brush with dissolved pigment; these overlapped the reserved whites in a few places.*

Above and left. *Two good examples by Francesc Florensa, showing the quality wax crayons are capable of producing when they are applied directly to the paper and then diluted with turpentine using a soft-haired brush. The middle range of tones look similar to those produced by water-soluble colored pencils, although wax crayon color is perhaps more luminous.*

A floral subject in wax crayon

A composition study

Before starting work on the actual picture, Ester Serra made a few preliminary studies based on the subject you see in the photograph on the right. Her intention was to find a viewpoint that offered her the most balanced composition within a square area. She decided to work from the viewpoint from which the photograph was taken. The compositional study not only helped to establish a balance between the different planes and volumes, but also defined certain areas of tone and color. In this floral theme, the shapes described by the various elements approximately determine the main areas of color.

Right. Preliminary study carried out by Ester Serra, on which the compositional construction has been indicated. Notice that the arrangement of the elements revolves around dividing the square into different triangles. You will see that each triangle corresponds, more or less, to one of the main colors.

Zone A: Background triangles, predominantly pale gray.

Zone B: Triangle containing the color green.

Zone C: Triangle containing most of the flowers. Red.

Zone D: This corresponds to a more stable element—a square—which is predominantly white.

Zone E: Dark gray triangle corresponding to the drapery beneath the flower pot.

Zone F: Small triangular area at the base, pale gray in color.

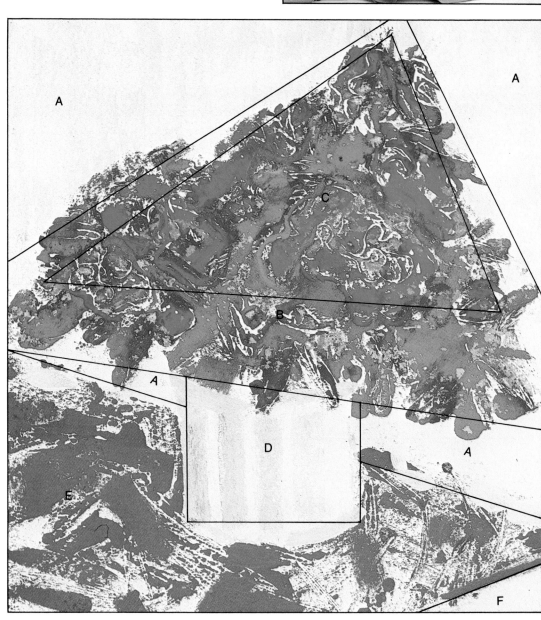

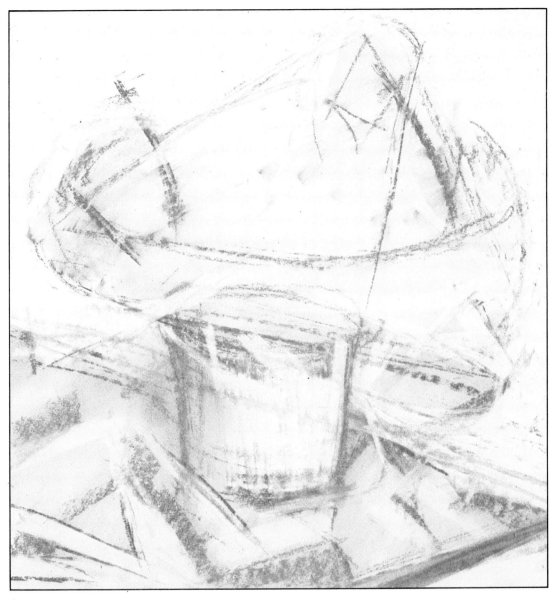

Layout sketch

On a textured paper, similar to Ingres paper, our artist made a layout sketch of her subject, using an earth-colored pastel stick. The fact that she has used a pastel and not charcoal allows her to apply wax crayon on top of a subtle base color that will breathe through without dirtying later color applications.

Left. Sketch of the subject made by Ester Serra using a burnt sienna pastel. Observe the simplicity with which she interpreted the compositional layout of the previous page.

Bottom left. Close-up photographs taken during the application of the first areas of color (step 1). See how the wax crayons are applied, flat against the paper, so that their whole length is used. The intention is to block in color, rather than to define form.

Step 1

Ester Serra has started by blocking in the gray of the basecloth and the red of the flowers on top of the previous sketch. These form a link through color between two of the main triangular areas of the composition. The method of working is illustrated in the two close-up photographs on the previous page.

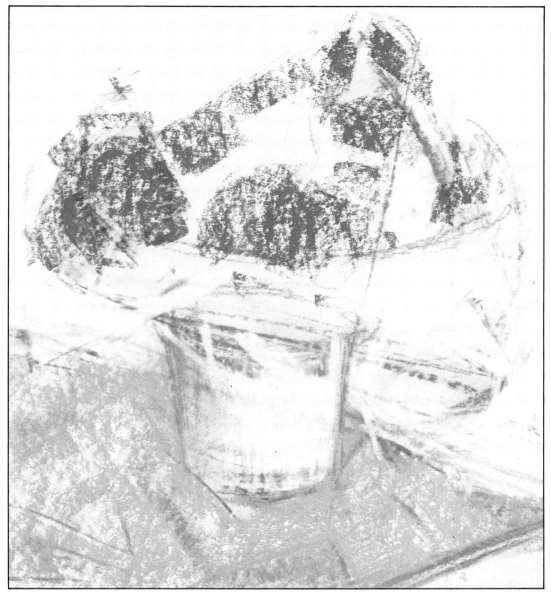

Right. How the picture looks after the color of the two main areas of the composition were blocked in. At this point the advantage of having made the base sketch in sienna pastel rather than charcoal becomes clear.

Bottom right. In these two close-ups (which correspond to the second stage of the picture's development) you can see how the colors were blended after being applied directly with wax crayon. A hog's hair brush loaded with turpentine was used to produce this effect. The tip of the crayon is applied (far right) to build up tone and define form.

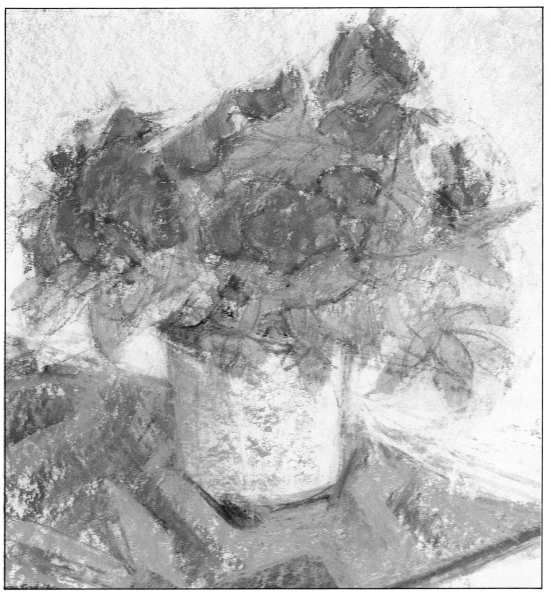

Step 2

The artist began the second stage of her demonstration by coloring in all the leaves around the flowers in bright green. She then reinforced in reddish brown the folds in the drapery that appear in shadow. After working directly on the picture in wax crayon, she blended the color using the methods described in the two close-ups on the previous page.

This technique of blending the pigment has been used extensively on the leaves and flowers where there is a greater variety of shades and where the forms are more complex and irregular.

Ester Serra gave the background a brown base color on top of which she applied a thick layer of white wax crayon. This superimposition of color created the warm gray seen in the photograph. The brown she used for the background is the same as the one used for the shaded areas in the folds of the drapery and also in the first touches of color applied to the vase.

Left. Close-up photographs taken during the blending, with the help of plenty of turpentine, of the white and brown colors of the background, after which neither the texture of the paper nor that of the wax pigment remain visible.

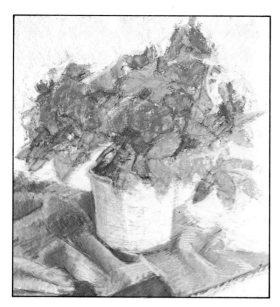

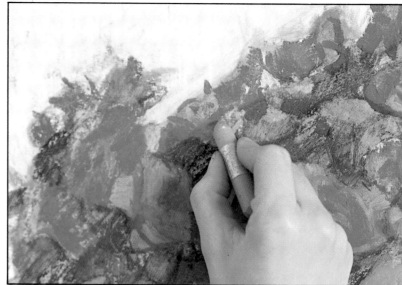

Step 3

This shows a transition stage during which the artist worked on making the drapery beneath the vase more substantial and on defining more sharply the different parts of the plant. She outlined in white the edges of those parts that stand against a white background, and in violet those in shadow. Notice in the illustration directly above that the vase has been given greater volume through a subtle gradation of grays around its surface, with the brown of the background breathing through.

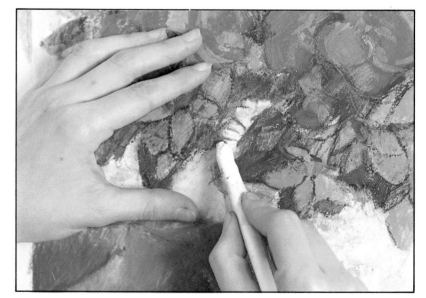

Step 4. Final stage

In the final step of Ester Serra's picture she enriched the color and clarified some of the forms that, until now, were still a little vague. Look at the three close-up pictures on the right and in the finished picture on the opposite page, and observe the colors used in the different areas of the composition:

In the flowers: On a base of uniform red, the artist worked with ochre, deep carmine, gray, and orange. *On the leaves:* On top of a green base there are touches of Prussian blue, ochre, violet, and deep green. *On the drapery:* Over the brownish-gray of the darkest areas, touches of violet have been added. Prussian blue has been used to outline the edges of some of the folds. More pigment has been added to build up the highlighted areas of the folds in the cloth over the base gray color and white. The colors were applied directly with the crayons and then a torchon was used to even out the color of certain areas: Look at the second of the three close-ups.

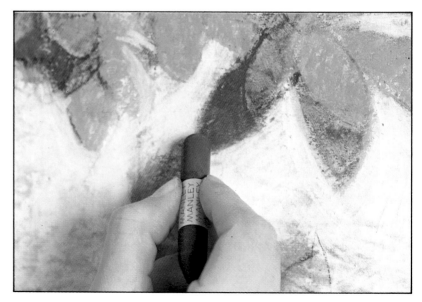

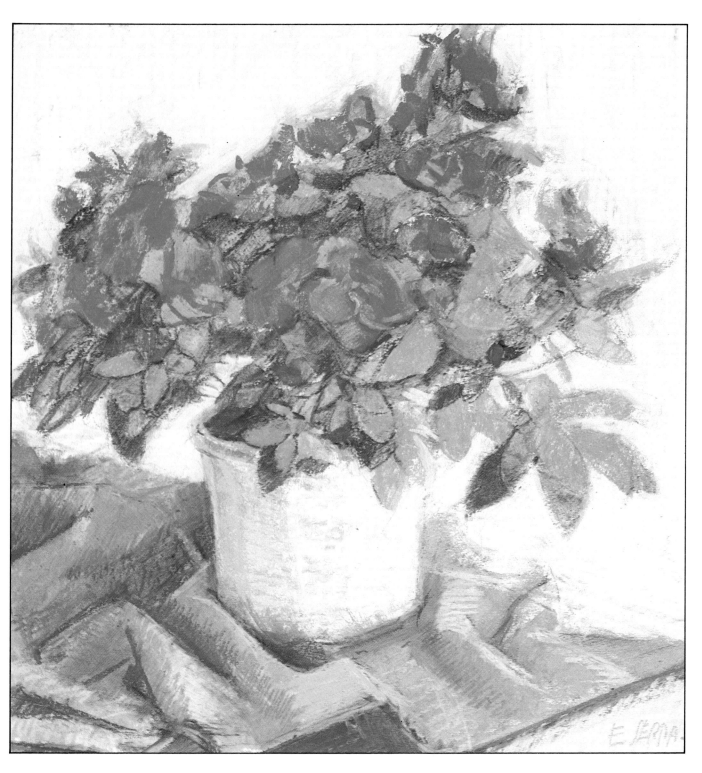

In the finished work the harmony of color is easy to see. Throughout the picture the background brown breathes through (this in itself is a harmonizing influence) and there are no violent contrasts. The carmine color in the drapery represents a visual link between the violets on the leaves and the reds and ochres of the flowers, preventing any feeling of a sudden impact between the two.

Left, opposite page, from top to bottom. Working in ochre on some of the flowers to suggest a fore-shortened view of many of the petals. Notice how the light falls differently on them. The torchon being used on the leaves is to give a greater feeling of depth. *Prussian blue being applied on top of one of the violet-colored leaves. Deepening the color brings the viewer closer to the picture. In contrast, those parts softened with the torchon tend to recede.*

Above. The finished work. Each area of the composition has been treated in a different way.

Still life in wax crayon

Wax crayons as we know them today, presented as solid colored wax sticks, are relatively modern. They can be used in a way similar to colored pencils although, in the hands of an expert, they can produce more pictorial and less draftsman-like results. In addition, the possibility of dissolving them in turpentine makes them a very versatile medium.

Other techniques with wax crayons

Modern crayons have virtually eliminated the technique of encaustic, which is hardly surprising given the complications involved in employing it. Encaustic is a method of mixing colored pigment in hot wax and then applying it (generally on a wooden surface) with spatulas and other implements heated to ensure that the wax stays in a melted state. In addition to this, the wooden support often needs to be kept at a temperature that prevents the layers of wax applied from becoming totally hard while work is in progress. As you can imagine, this is a slow and difficult technique.

Wax crayons are much easier to apply and are perfect for working on paper with a deeply grained surface. Varying textures may be obtained by juxtaposing areas of dense color (which penetrates the paper surface completely) with others in which the grain remains clearly visible.

This is one method employed by Juan Sabater in producing the still life we are about to show you. This work will be an example of a classic way of dealing with composition as well as being classic in its conception. As always, we would like you to regard this exercise as compulsory, although, of course, you are free to use it merely as a guide for your own work. If you prefer, set up your own still life, but interpret it in wax crayon following Juan Sabater's methods.

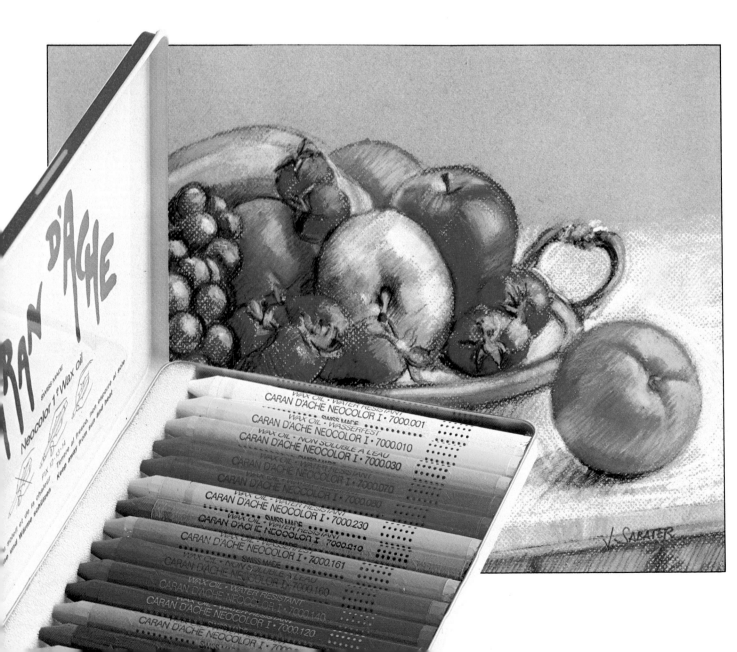

Two examples from masters of the medium

Left. Abstract composition by Josep Maria Avila, encaustic on wood. Encaustic is a pictorial technique now considered as "historical," as egg tempera and fresco painting.

Below. Still life drawn in wax crayons by José Maria Parramón on a medium-textured Canson watercolor paper. Notice the pictorial quality achieved by applying successive layers of color (without fear of exerting too much pressure) and by working the surface extensively with the fingers. The warmth of the hand softens the wax and makes it possible to produce beautiful effects with blended color.

The composition

Take a look at the fruit you have in your refrigerator and arrange some in a still life in which yellows and reds are the dominant colors. If you are lucky enough to find some fruit with a violet color, such as the grapes Sabater has used (figs will do nicely too), you will be able to counterbalance the predominantly warm color scheme with a cooler element. Notice how in our composition the orange on the right balances the excessive weight that the bunch of grapes gives the left half of the picture.

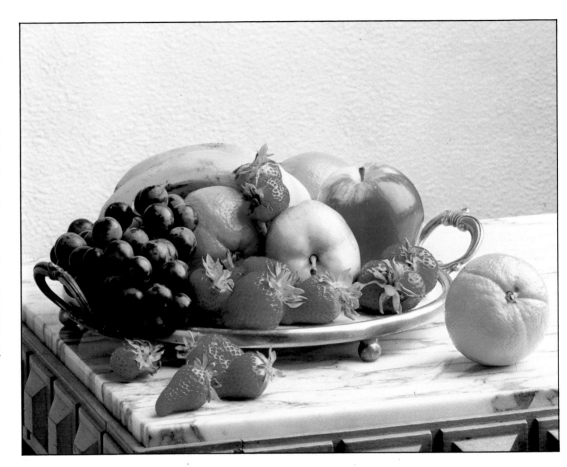

Layout sketch

Use a sheet of medium-textured Canson watercolor paper, about 10 × 14 in. (25 × 35 cm). Try and find a pale, warm gray-colored paper like the background of the photograph, so this can become the base color in your picture and save having to draw it.

On this paper, with a few fairly general lines, locate the main areas of the composition: The more or less oval shape of the arrangement of fruit, the sphere of the solitary orange and the triangle formed by the three strawberries. Work with a black-colored pencil, as charcoal or graphite will prevent the wax from adhering to the paper surface.

Preliminary drawing

Using the layout sketch as a base and with the same black-colored pencil, Juan Sabater has built up a line drawing in which each element of the picture is perfectly situated and its outlines are defined.

When you reach this stage in your own still life, try to smudge the drawing as little as possible. Work carefully, putting little pressure on the pencil while establishing the position of each fruit. Once you are sure of its shape, size and location, you can firm up your drawing using a much harder, thicker line.

Left. Close-up of the line drawing. In this full-size illustration, you can see how heavy and thick the lines are.

Below. Line drawing produced prior to applying color. As you will see later, the black outlines will still be visible in the finished picture.

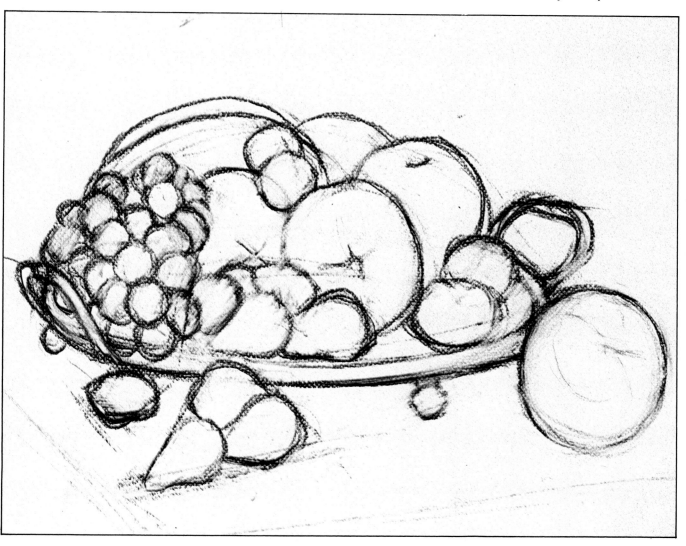

Right. *Close-ups showing the first layer of base color being applied to the fruit, mainly yellow-orange and vermilion. Notice that a less bright color has been used for the red fruit: A burnt sienna, in fact, which has been lightly applied.*

Below. *Sabater's work after the first application of color. Observe how the artist has tried not to penetrate the paper surface. For the moment, the texture of the paper is visible through each area of color.*

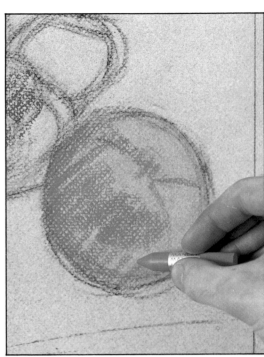

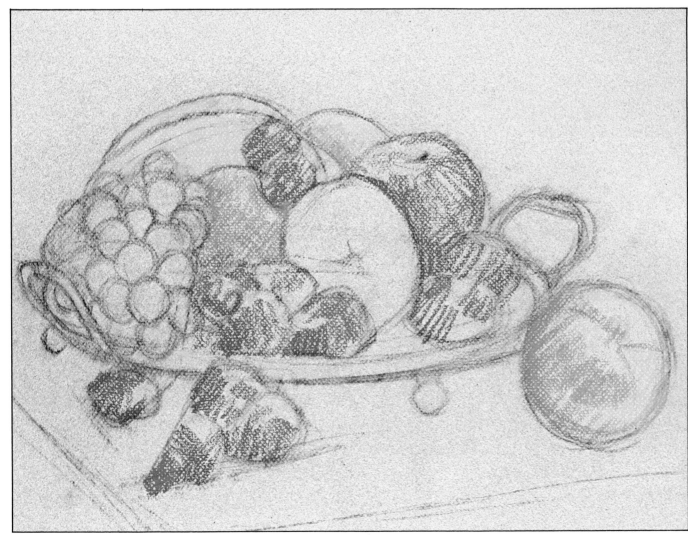

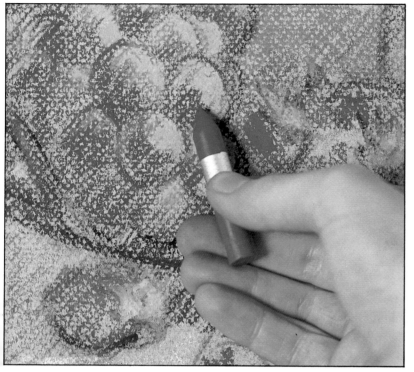

General application of color

After blocking in the first areas of color with cadmium yellow, cadmium orange, and burnt sienna (see the illustrations on the previous page), Juan Sabater continued to work on the general, definitive coloring of his composition. Study the grapes. They have been given a base color of ultramarine blue while in the darkest areas, a layer of carmine has been laid on top. Deep vermilion has been applied very skillfully; pressure has been exerted where it was appropriate for the color to be quite thick (in the darker places), whereas in the most brightly lit areas (such as on the strawberries), the grainy texture of the paper has been left clearly visible.

Left. A layer of carmine being applied in the areas in shade, on top of the blue base color of the grapes.

Below. General look of the still life after the main areas of color have been blocked in. Note the two different textures already visible at this stage.

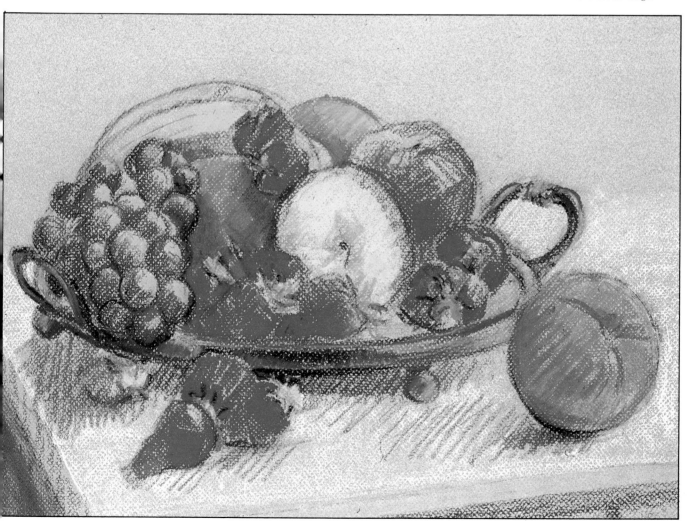

Final evaluation of tone

After the general color was laid in, as shown on the previous page, Juan Sabater began to work on the nuances of color and the highlights that gave his finished picture the look he sought. He worked at building up the pigment (ingraining the wax into the paper) in those areas that appear as highlights (see the original photograph of the subject on page 80) and he also applied white wax crayon to those parts of the picture that demanded more sophisticated gradation or reflected highlights: On the scarlet-colored apple, on the grapes, and some of the strawberries, for instance.

Notice a few details: The background has not been colored. The artist has used the color of the paper itself, without any modification. The black outlines of the preliminary drawing, although slightly obscured by the color, still play an important role in describing the different forms.

The same colors that dominate the composition appear on the table top. Shades of the colors of the fruit are visible in the white marble and this contributes significantly to the overall chromatic harmony of the picture. Finally, notice the two ways in which the wax crayons have been used. As we said at the beginning of this exercise, Sabater intended to create a counterpoint between the smooth texture of the pigment itself when applied thickly and the more vibrant texture of the paper's grain when it is allowed to show through.

Below. *Close-up showing the contrasting textures described above.*

Right. *The finished picture. A good example of wax crayon work.*

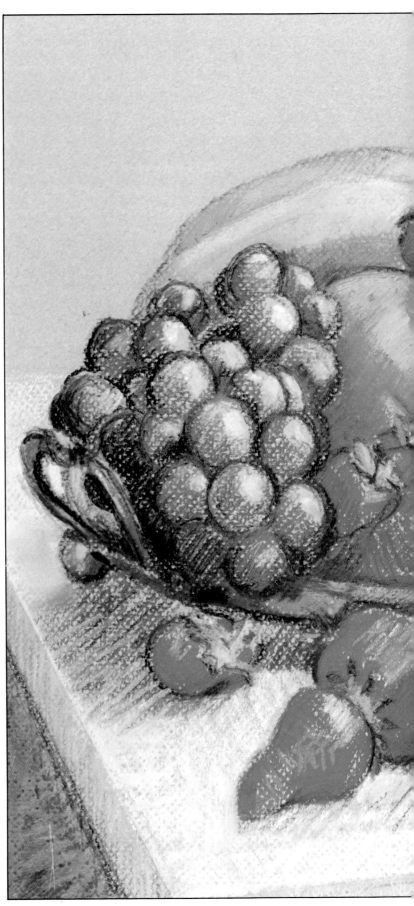

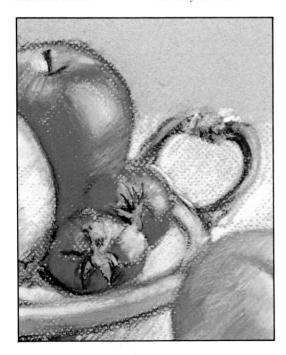

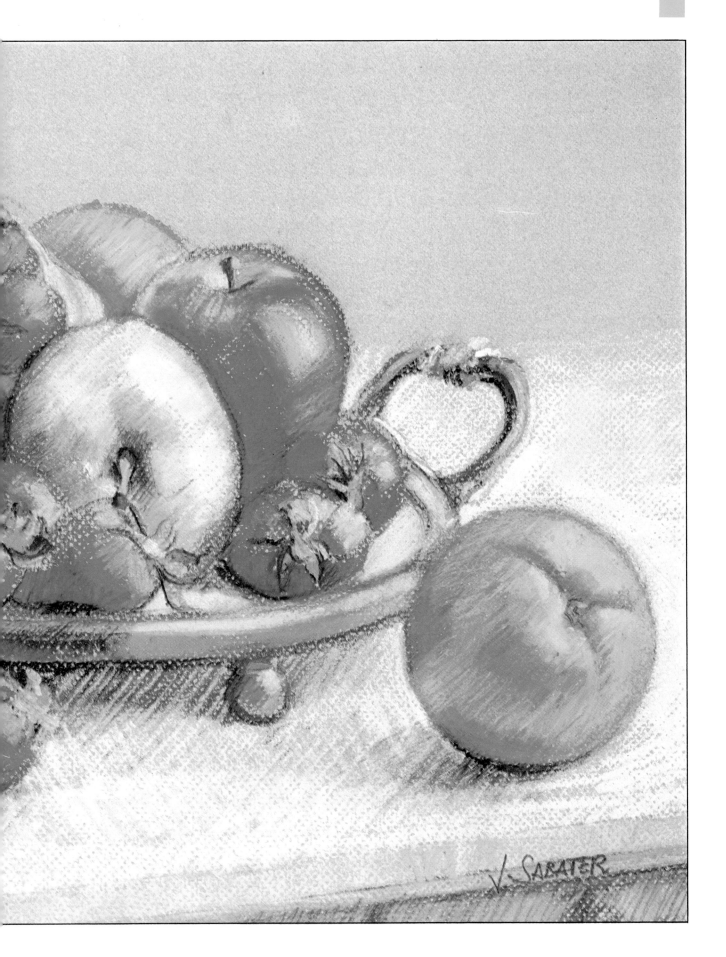

Five special techniques

The application of any pictorial medium might be called an original technique. Any technique adapts to the characteristics of the medium being used. The technique of oil painting, for instance, consists of applying it with a brush onto a canvas, regulating the thickness of the color with linseed oil or turpentine. However, we all know that oil colors may be applied in many different ways: With a spatula, using an impasto technique, overlaying thin washes of color, mixing the pigment with gypsum powder to create textured surfaces, and so on. With any pictorial process, techniques can be found that depart from traditional methods and offer unexpected and sometimes very attractive results.

Wax crayons are no exception—quite the opposite, in fact. Wax crayon is a medium that particularly lends itself to the exploration of new methods and techniques. Besides the traditional method of using the crayons, in a way similar to pencils, a series of techniques is possible that we have decided to call "special," for want of a better word.

Our goal in choosing these examples is to introduce you to five different ways of using wax colors. We are not going to ask you now to do any specific exercises (we will do this later on), but we will try to show you some tricks you might be able to put into practice when working by yourself. We will also present you with some examples demonstrating each special technique.

You will need the equipment shown in the photograph below: A selection of wax colors (a box of individual crayons), a piece of cheap canvas, a fine-haired brush (No. 8 or similar), another hog's-hair brush (No. 12, for instance), some watercolors or gouache paints, and a bottle of turpentine.

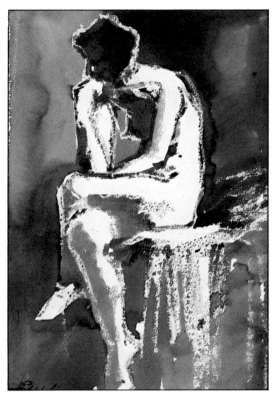

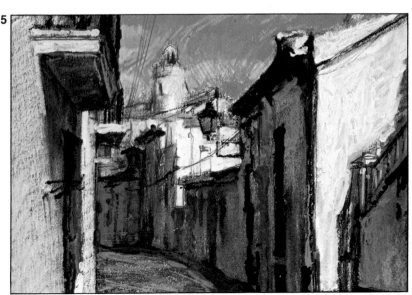

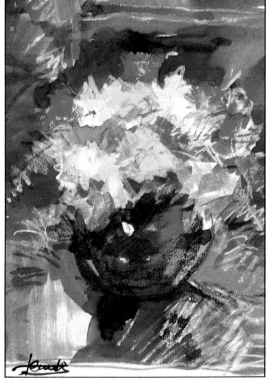

1. Watercolor figure drawing using the "negative" technique with wax.

2. Floral theme painted in watercolor showing various "negative" effects obtained by using wax.

3. Seascape in wax crayon showing the effect of scratching out and of applications of turpentine.

4. Landscape in wax crayon with scratching out on layers of superimposed color.

5. Village street in wax crayon with applications of diluted pigment.

1. Working in negative

With some ordinary or paraffin wax (you might use the stub of a candle, for instance), cover parts of a piece of medium-textured Canson paper. The wax will reject any water-based color applied on top of it and will give you some attractive negative effects showing the original paper color.

2. Working in negative with different colors

On a piece of coarse-grained paper, make patches of different colors using wax crayons. Go over these with a wash of black paint, which will only be absorbed where there is no wax.

3. Using turpentine

Apply wide lines of wax crayon on a piece of fine-textured paper. With a sufficiently wide hog's-hair brush loaded with turpentine, brush over these lines. A uniform and transparent effect is produced.

4. Scratching out

On any base color (red, for example) apply another, darker, color. If you scratch the surface with a scalpel or a razor blade using different strokes, you will reveal the color underneath.

 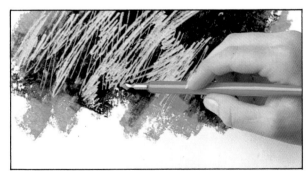

5. Melted wax

Wax melts when subjected to heat. Take advantage of this to produce lumpy-textured surfaces and layers of brilliant color. Apply the color when the wax is soft or by allowing it to drip onto the paper.

Working in negative

Although it may appear to be the case, this is not an intuitive work but, rather, a carefully considered one. The artist begins with a sketch, executed with the greatest precision, in which the outlines and shaded areas are perfectly defined.

Notice that the wax has been applied with the aim of covering (though not too precisely) the illuminated areas of the drawing.

Another observation: The washes have been applied using the wet-into-wet technique, beginning with the lightest tones, and superimposing darker shades. The different tonal values in the background make a powerful contribution to the visual impact of the picture. The darkest tones are adjacent to the most illuminated area, while the lighter parts fall alongside the darker shades of the head and chest, lending a sense of depth to the picture.

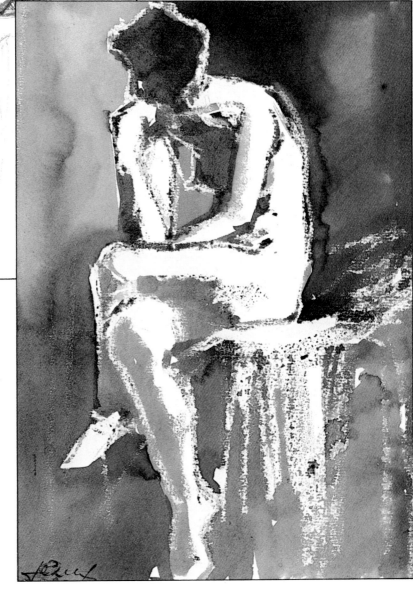

This technique may be used in combination with others to achieve a particularly effective touch within a picture. The artist may choose to make this effect the focal point of a picture, as is the case in this magnificent example by Miguel Ferrón. Using this method involves sacrificing precision in order to convey a feeling of form, created by a negative image of vague outlines.

Nonetheless, the resulting image may well be an attractive vagueness, a visual impression that suggests unequivocally a certain form and pose, without leaving the viewer in doubt as he or she contemplates the washes of color and contrasting areas of white.

Above. *Pencil sketch used as a basis for the application of wax and the washes that were laid over it.*

Right. *Watercolor by Miguel Ferrón with negative areas drawn in wax.*

Working in negative with colors

forms, it demanded a great deal of thought from the artist. This does not mean, however, that he has abandoned his intuition. Look particularly at the white areas: They have been obtained by using the negative technique, which means that their size and position in the picture have been thought out in advance. It is important that, when preserving areas with wax (on white paper), the artist keeps a mental image of what he or she hopes to achieve. Despite having the pencil sketch to refer to, this kind of work requires constant thought to prevent the liquid color wash from spreading into areas intended to be negative. This could result in the loss of the initial idea as well as overall control of the picture.

Remember that the basic idea is to cover with wax pigment those parts of the picture that require a particular color and that must not be affected by later washes applied on top of them. The idea is not to obtain a negative image, as in the previous example, but rather to cover up specific areas of color, to protect them from the effects of the water-based paint. In this example by Miguel Ferrón you can see the skill with which he regulated the pressure applied when laying down the areas of wax color. Some parts are completely opaque while others show "pores" into which the watercolor penetrated so that when dry a grainy appearance can be seen in parts of the finished work. On this occasion, too, the artist used as a guide a pencil sketch in which, applying bold strokes, he indicated the main tonal values he wished to maintain in his colored version.

Although this seemingly carefree work seems to be an intuitive color sketch with its vague

Using turpentine

For an artist, "turp" is a familiar piece of professional slang. Turpentine essence is used in various painting techniques and may be applied over wax crayons. The usual method of doing this is demonstrated in the example provided for us on this page by Miguel Ferrón. Whether working from a photograph (see right) or directly from nature, the goal is to make a crayon sketch in which the forms are clearly defined (there can be no subsequent modifications), and to which the first touches of color have been applied.

Once this is complete, you can get to work with the brush and turpentine. Using various

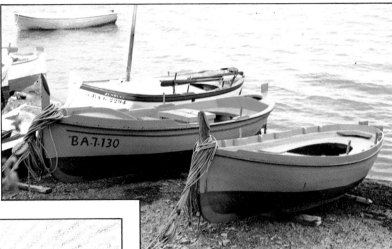

brushes, soft- or hog's-hair according to your requirements, the wax is dissolved on the paper. Drag the color to give direction to the brushstrokes or allow different pigments to blend together. Soft-haired brushes will give uniform brushstrokes, whereas hog's-hair brushes will leave drag marks on the paper. The brushstrokes contribute to the drawing process and suggest the texture of different materials, such as the sand on this beach.

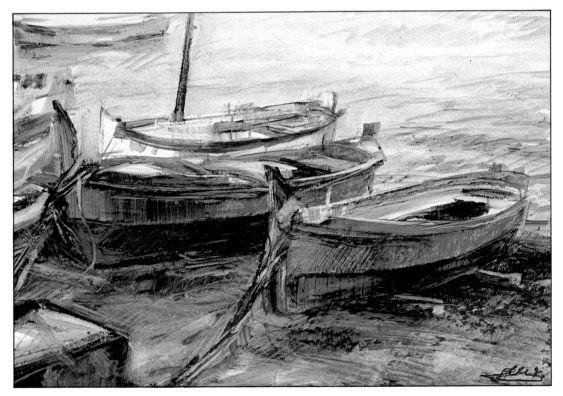

Left. Seascape in wax crayon with turpentine washes, produced from the colored sketch you see above. Notice the difference between the way the sea (soft turpentine washes applied with a sable brush) and the beach have been treated. To represent the harder surfaces, Ferrón used hog's-hair brushes, taking advantage of the marks they leave to show the texture of the sand. In the case of the boats and the ropes, he used the scratch technique to good effect.

Scratching out

meticulous approach to produce fine, parallel lines or cross-hatching if you want to represent minute detail. In either case, the process itself will be similar: A preliminary tonal sketch will help you keep sight of your original idea. When applying layers of wax, the usual method is to work from light to dark. This does not preclude the possibility of reversing the process in certain areas or to achieve different effects.

Scratching out is a technique with which you can have a lot of fun. It is always possible to find a new shade or a new effect by using a different color or stroke. The artist may get carried away, but it is important to guard against this and not to turn a serious and well-considered piece of work into a jumble of unrelated details.

As explained a little earlier, the scratch technique in wax crayon drawing consists of revealing an underlying color by scratching a superimposed color away. A variety of strokes are used.

Ester Serra has given us one example of this technique. She worked in her own way as you, no doubt, will work in yours. With practice, you will find your own style, which will give character to the drawings in which you use this technique.

You can use the scalpel or razor blade decisively, even furiously. Or, you can adopt a

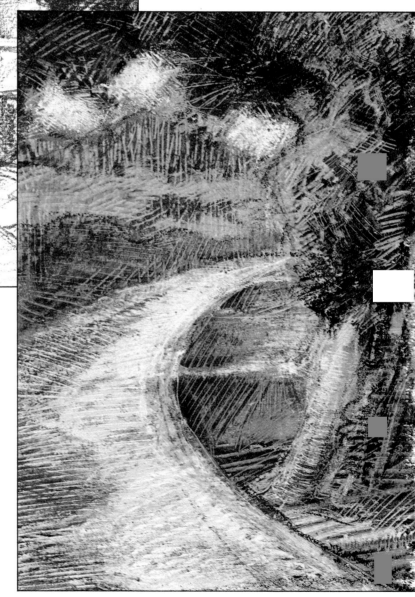

Right. *Scratched out landscape in wax crayon drawn by Ester Serra. Look closely at specific areas (the tree, the road, the road side, and so forth) and you will see that there are up to three layers of different colors in some places.*

The melted wax technique

To the layman's eyes, this final picture in our exploration of wax crayon techniques might well pass for an oil painting. The thickness of the color applied to the support is more reminiscent of oils than any other pictorial medium. However, this village street has been drawn by Miguel Ferrón entirely in wax crayon.

The method is simple: Whether you are working from a photograph or from nature, you first produce a wax crayon drawing of your chosen subject in the traditional way—by rubbing the crayons directly on to the paper and, at

the very most, using your fingers to blend or gradate the color.

The next step is to apply the layers of melted wax color. You will have to bring your wax crayons to their melting point (you can do this with the flame of a cigarette lighter or a candle). The colors must then be applied to the surface of your picture before they become hard again. In this way some wonderfully luminous layers of thick color can be created, especially when seen in contrast with a different background color. Be careful not to go overboard with this technique, though. Limit yourself to applying melted wax in just one or two colors and only in specific areas of the picture.

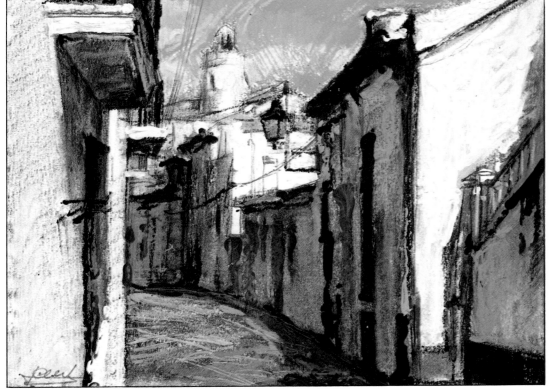

Left. Village street. Wax crayon drawing with layers of melted wax.

Notice how the artist restrained himself, using this technique only for certain areas of white, (on the brightest walls), ochre, and scarlet. See how the thick coat of melted white wax on the wall shines out against the ochre base color.

Still life in wax crayon, working in negative

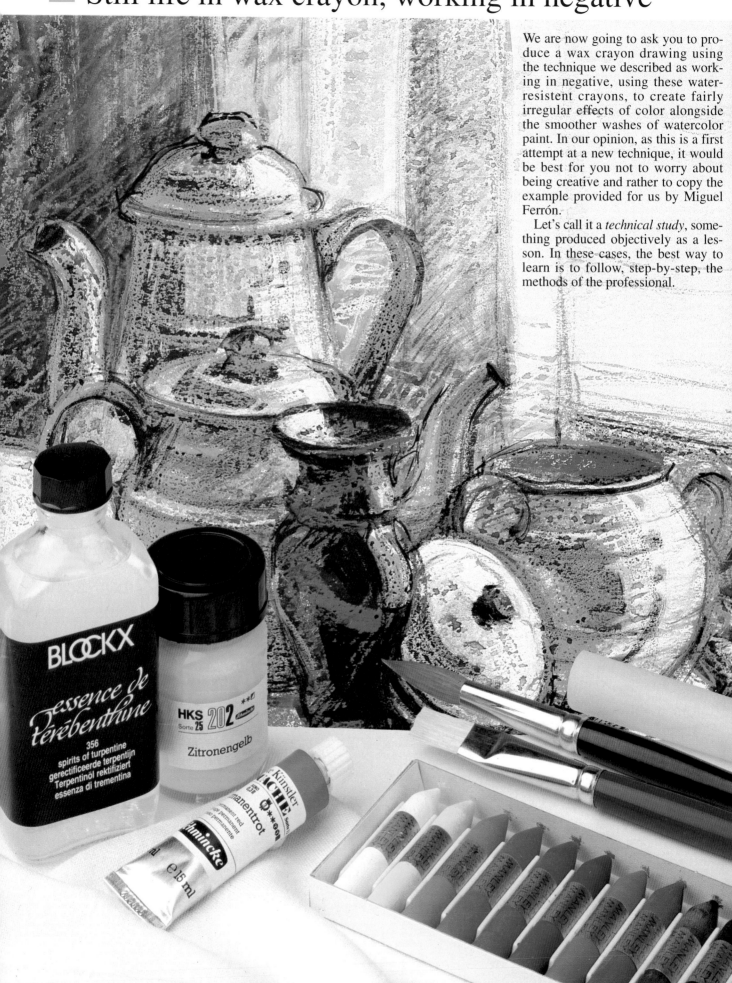

We are now going to ask you to produce a wax crayon drawing using the technique we described as working in negative, using these water-resistent crayons, to create fairly irregular effects of color alongside the smoother washes of watercolor paint. In our opinion, as this is a first attempt at a new technique, it would be best for you not to worry about being creative and rather to copy the example provided for us by Miguel Ferrón.

Let's call it a *technical study*, something produced objectively as a lesson. In these cases, the best way to learn is to follow, step-by-step, the methods of the professional.

Layout sketch and initial applications of wax

On textured Schoeller paper about 14 × 20 in. (35 × 50 cm) make a layout sketch in wax crayon of the still life arrangement shown in the photograph on the right. Do this as Miguel Ferrón has done his, paying careful attention to proportion and perspective. Produce a loose, soft line drawing that outlines the forms of each element of the composition accurately enough to avoid the need for corrections later. From this point on, technique and color are all you will need to worry about.

Below. Layout sketch of the subject. Notice how the strokes, although quite free, conform precisely to the laws of oblique (two-point) perspective.

Below and right. Close-up of the artist applying a negative area, in white wax crayon, to indicate the reflection of light on the teapot.

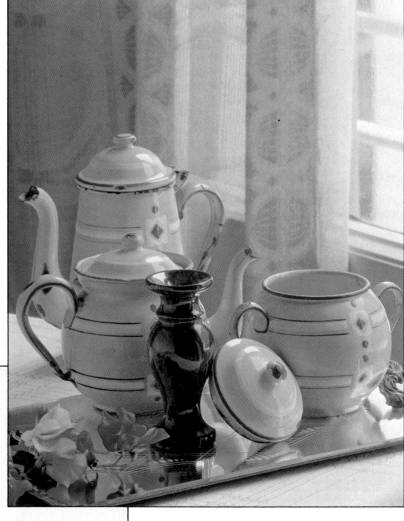

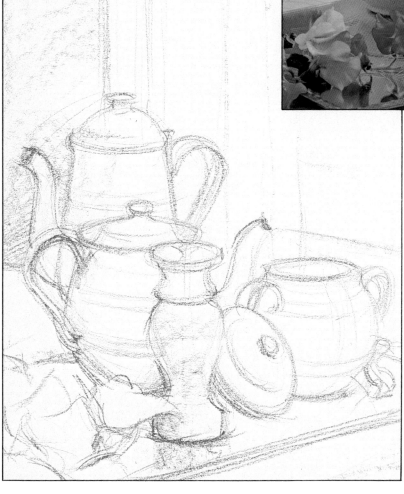

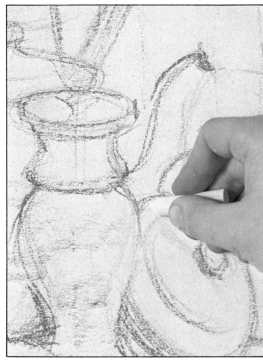

Color negative areas

Remember: Working in negative with wax crayons is based on the fact that wax rejects any washes laid over it. On the next two pages you see that the second stage in the development of Ferrón's picture consisted of applying wax crayon that was retained as a negative element. It was interwoven with watercolor washes that penetrated the paper surface in those areas where there was no wax.

Like Ferrón, you should begin by applying the lightest colors, without exerting too much pressure on the paper. You should build up color on the paper gradually, because an excess of pigment will leave the surface so impermeable that subsequent washes will hardly have any effect. At this stage, try to envision the finished picture in your imagination, so as to leave free of wax the right amount of space for the washes to penetrate. On the right is Ferrón's work after this first stage of applying wax crayon.

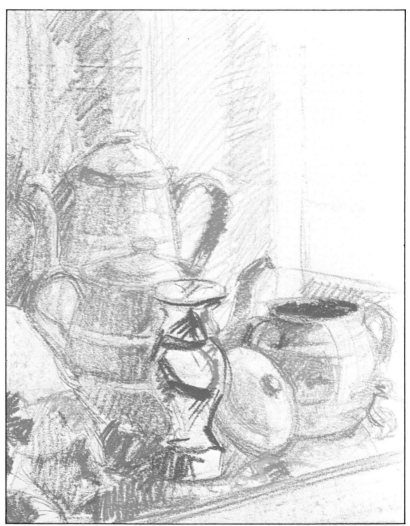

Above. Section of the background showing light touches of ochre applied on top of a few strokes of blue.

Right. Filling in with red the shapes that correspond to the flowers in the bottom left-hand corner of the picture. Notice the irregular texture of the color and the large surface area still available to absorb the watercolor wash about to be applied.

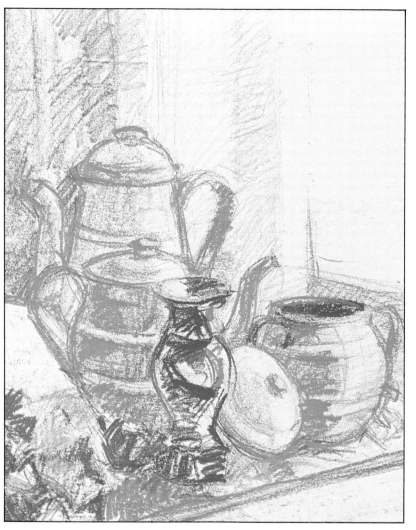

Notice that one of the artist's preoccupations was not to overdo the amount of wax color he applied. He was very cautious in this respect. Although the photographs on this page show that Ferrón built up color in some areas to add a sense of volume (there is by now a greater contrast between the white highlights and the colors of the objects themselves in the areas hidden from the light source), a lot of the picture surface is still untouched.

When you reach this stage, consider that, once the first washes have been applied and have dried, you can always add new touches with the wax crayon that will adhere quite readily to dry watercolor.

Although there is not a huge difference between the photograph on the previous page and the one you see here, in the second you may notice the addition of further touches of blue, violet, and burnt sienna.

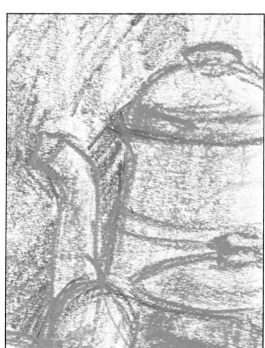

Left. *Building up color on the grainy paper with blue wax crayon, in the area of the pot turned away from the light.*

Above. *Close-up showing the unfinished look of Miguel Ferrón's wax crayon picture at this stage.*

The first washes

The technique we are currently exploring is one of many mixed-media techniques in the art of painting. We are combining wax crayons and watercolors and it would be fair to ask which of the two should take priority: Are we making a wax crayon drawing with watercolor wash? . . . or a watercolor painting with touches of wax crayon?

The truth is that both are equally possibilities; the answer to the question depends on the artist's personal vision. In the specific case of Miguel Ferrón's example, both media are of equal importance. You will be able to see this for yourself as he begins to apply the watercolor wash.

Another thing: You may be surprised by the early effects of the wash; with this technique, they are always unpredictable. Although the crayon work has been carried out with an eye to the final effect, that effect is unlikely ever to be exactly as expected.

Above, right. Applying an initial wash of Prussian blue to the pot. The whites and pale blues are the marks of the wax crayons. The dark, mottled effect corresponds to the watercolor absorbed by the paper. You will notice that the texture obtained is always irregular and, inevitably, unexpected.

Above. Pink wash being applied to the vase and the teapot.

Right. A burnt sienna wash being applied to the background in the top left of the picture. The texture and the nuances of color depends on the wax; the results are always unpredictable.

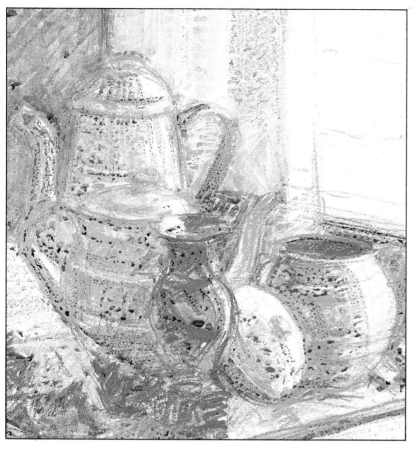

On the left is a photograph of Ferrón's work after the first applications of watercolor wash. Notice the tone, somewhere between pink and violet, of the base color in the vase and teapot. The artist quite rightly thought that the dominant color of the flowers (a kind of magenta) would be reflected in the surface of both objects. You can also detect an echo of the pink tone in the coffee pot. Naturally, in contact with the blue of these objects, the pink becomes more of a violet color.

Besides the three washes already mentioned, the blue, pink, and burnt sienna, Ferrón has also applied a fourth: Yellow ochre on the central background area of the composition. Notice the effect produced now by the strokes of blue wax crayon which Ferrón left visible when seen in contrast with the ochre wash.

It is also worth noting that the little specks of blue picked up by the brush give a pleasantly "dirty" effect to a background, which might otherwise appear too perfect.

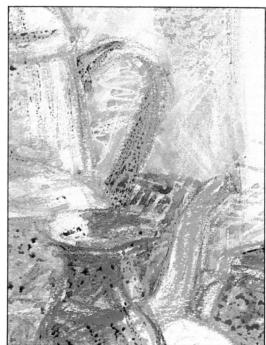

Left. *Application of a magenta wash over the area of the flowers. This same wash is also applied to the vase and the teapot and, in a more diluted state, to the large coffee-pot. This represents the color of the flowers reflected in the shiny objects and is a warm shade that tempers the coolness of the blue.*

Above. *Close-up of the ochre-colored section of the background. Notice that the irregularities in the texture of the background are caused by specks of the blue wax having "dirtied" the otherwise perfect (too perfect) yellow ochre wash.*

Last washes and finishing touches

From the stage shown on the previous page onward, Ferrón treated his work as an ordinary watercolor painting, allowing the wax crayons to dictate the spontaneous effects that happen naturally in this type of picture. In other words, once the first washes are dry, you should work without even thinking about the wax pigment underneath. Its water-resistant nature will reject the watercolor automatically. Use watercolor to introduce new tones and nuances of color.

Bring out the tonal contrasts as Ferrón has done with carefully controlled washes of dark gray. As you can see, the black, mottled effect adds interest to the general texture of the picture.

Finally, using Chinese ink (which will adhere to wax), give your picture the final touches, outlining form and heightening contrasts, particularly in the small, dark vase at the center of the composition.

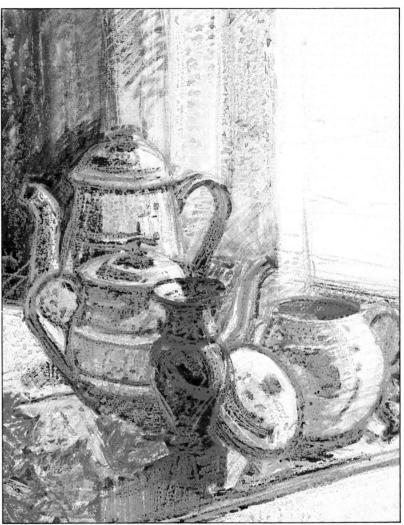

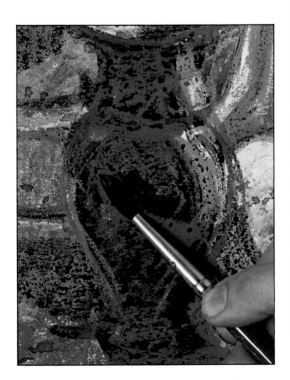

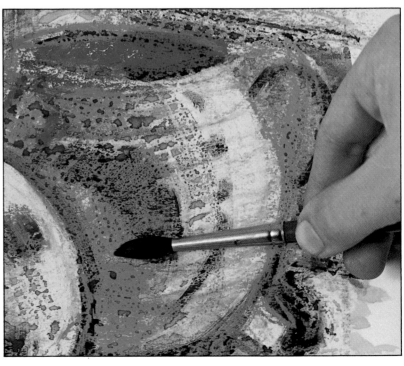

Above, right. Ferrón's work showing the new color introduced with the last washes.

Above. Intensifying the magenta watercolor wash on top of the blues and the vase in the center, which has been given a mottled effect with a wash of dark gray.

Right. The artist flecks with black a few specific areas of the pot, applying color in a very carefully controlled way so that it does not go further than intended.

Opposite page. The finished picture, showing the final touches added in Chinese ink.

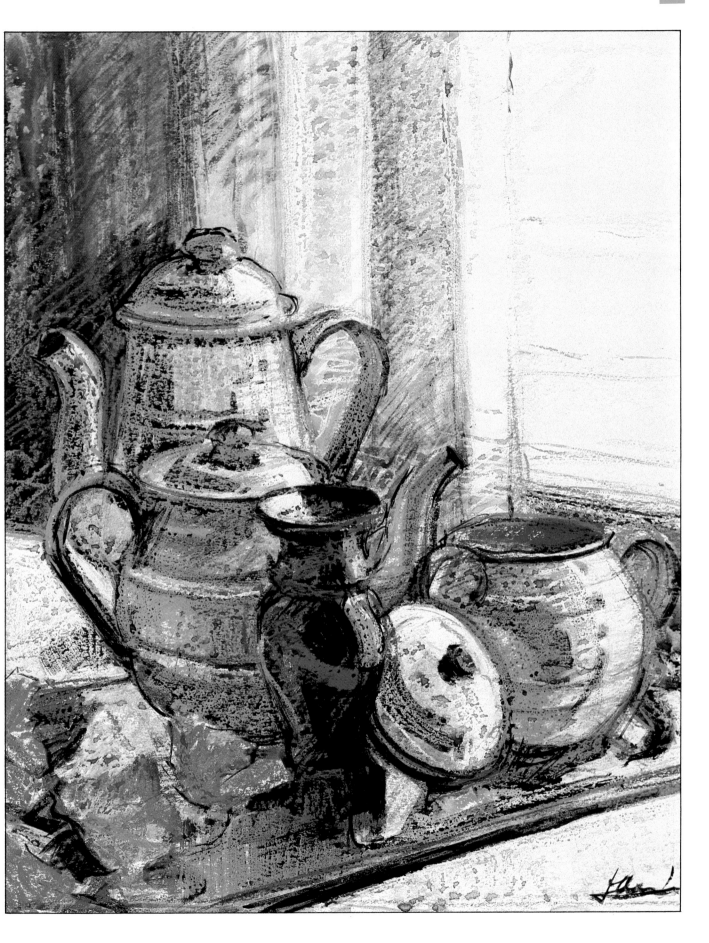

Landscape in wax crayon with turpentine wash

For this exercise we are going to use one of the five special techniques using wax crayon described on page 86. This one takes advantage of the fact that wax pigment is soluble in turpentine. We will use this to work with a brush on certain areas of color, to give uniformity to certain shades, or to blur some of the more obvious individual strokes.

We would like you to carry out this landscape in wax crayon, using a brush and turpentine for parts of the exercise.

As an example, we will show you the development of a painting by Juan Sabater. It is an autumn landscape in which the bright green grass provides a strong contrast with the golden leaves of the trees.

Our example is just that: Something for you to copy. You may paint your own landscape, as long as you use the same materials and follow the same steps as Sabater.

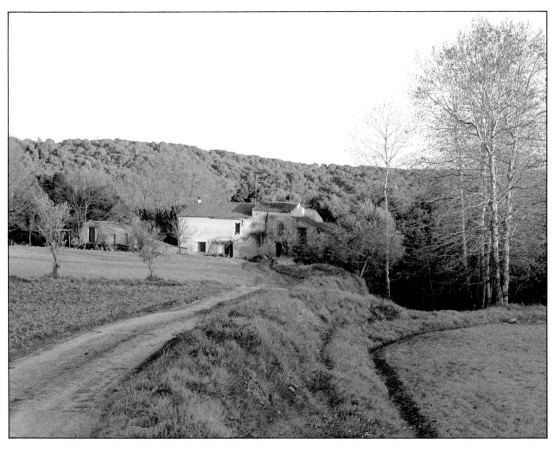

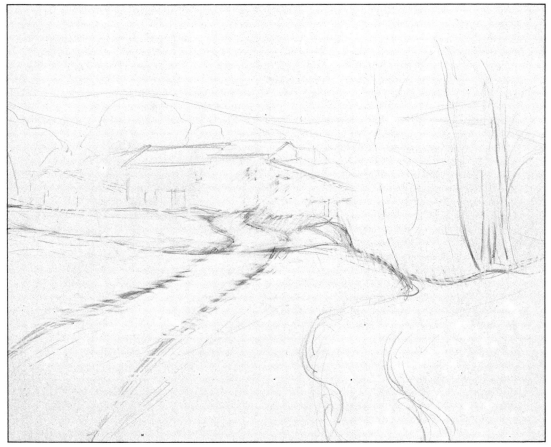

The layout sketch

As usual, the artist has begun this work by making a layout sketch. In this instance, Sabater used a fairly hard HB graphite pencil. He has been careful not to make too many pencil strokes because these could spoil the wax colors, especially as turpentine is going to be used which will pick up any traces of graphite. So with this in mind, Sabater has made a faint sketch, simply to indicate the essential elements of the picture.

Initial color

Sabater's second step is to introduce the first areas of subtle, warm color on which he will base the tonal and chromatic contrasts to be established later. If Sabater, with his customary enthusiasm when embarking upon a new picture, had allowed himself to overwork the initial pencil sketch, these pale, almost transparent areas of color would already have been spoiled by specks of graphite dust.

These early warm tones have also been applied with considerable restraint, given that the subject could easily have led to a generous but dangerously liberal application of color. At this stage, the artist is still forming his ideas about which colors he is going to use and the order in which he is going to superimpose them. Although one can scrape off wax crayons easily, it is also true that getting rid of color in this way leaves its mark; the color is dirtied in areas where pigment has been scraped away.

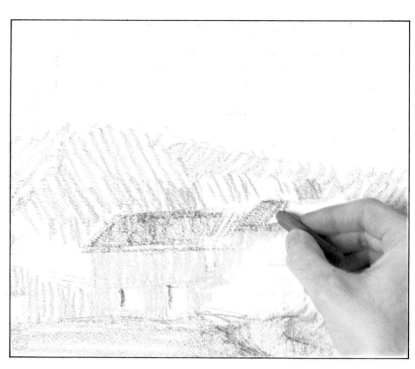

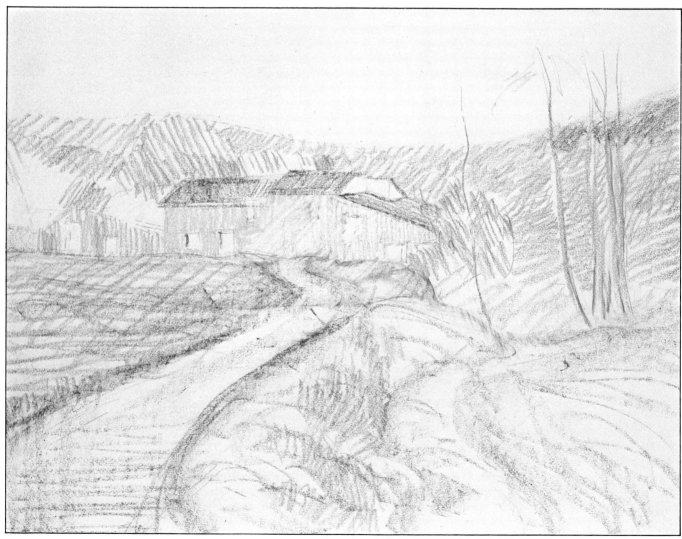

Continue to block in color as Sabater has done. Add a few cold tones on top of the base of warm colors to contrast with the ochre of the wooded area. Suggest the greens of the grass, the blue of the sky, and the uneven surface of the little road with its distinctly violet tinge.

Left. Photograph showing the artist superimposing green over the ochres and earth colors used to cover the field in the foreground. Notice that the wax crayon is being applied lengthwise.

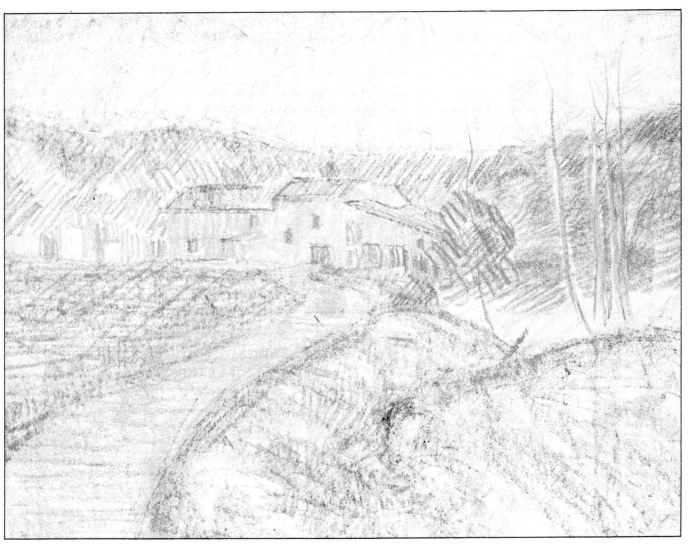

General turpentine wash

Once Sabater completed his soft base color, he decided that it was time to turn the rather irregularly applied strokes into a more uniform spread of color that, as with any wash, provided a good color reference for his picture. To achieve this, he used a flat, No. 12 hog's-hair brush and artist's quality turpentine. In the close-up photograph on your right, you can see that the liquid was applied directly onto the paper, the idea being to dissolve previously applied color. There is no need to dissolve the wax pigment on a plate before applying it. Using the method shown, you can achieve perfectly good coverage, uniformity and transparency of color.

Practice will show you that the brightness of the white paper surface will help you to regulate the transparency of your color while spreading it around or mixing it with adjacent areas of color.

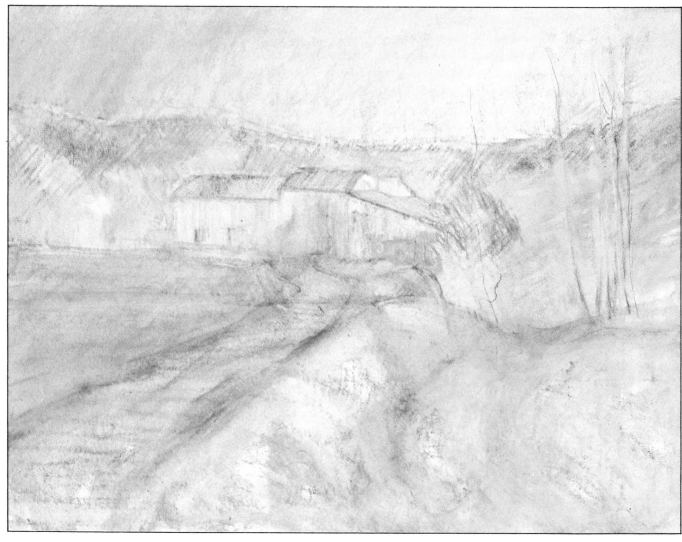

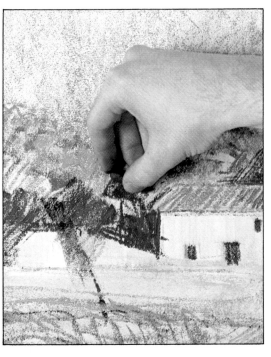
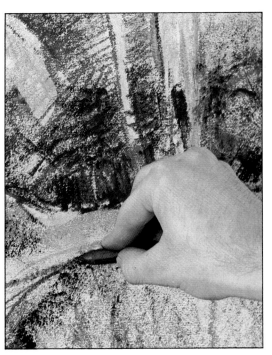

Dark colors

Working with bits of wax crayon of different sizes, Sabater has introduced the darker colors, both warm and cool. He has established a clear distinction between light and shade throughout the picture.

The end of this process (see below) marks the completion of the general tone setting. From the contrasts established at this stage, the artist will go on to enrich the colors of his painting.

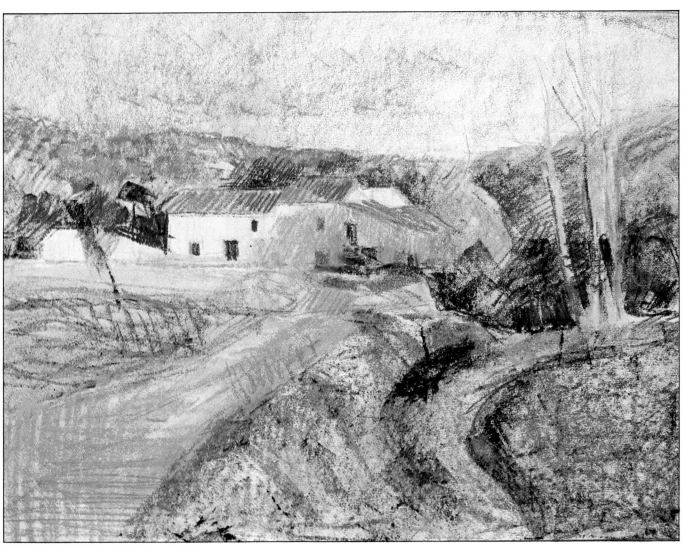

Final stage

Whites, grays, greens, blues, and yellows were used to fill in many of the gaps still visible in Sabater's picture after the application of the turpentine and the dark areas of the previous stage. He enriched the overall color of the picture, partly by applying wax crayon directly, and partly by using a brush and turpentine to dissolve existing strokes of color. Another technique used by the artist (especially on the grays of the road and the yellows in the grass) was to apply wax crayon to his chosen area before the turpentine was completely dry; the crayon became soft again and produced a very interesting, rather smudgy effect. In order to take advantage of this possibility, you have to work after the turpentine wash has been applied.

You can also dampen a small area with turpentine if you wish to produce this effect in one particular spot.

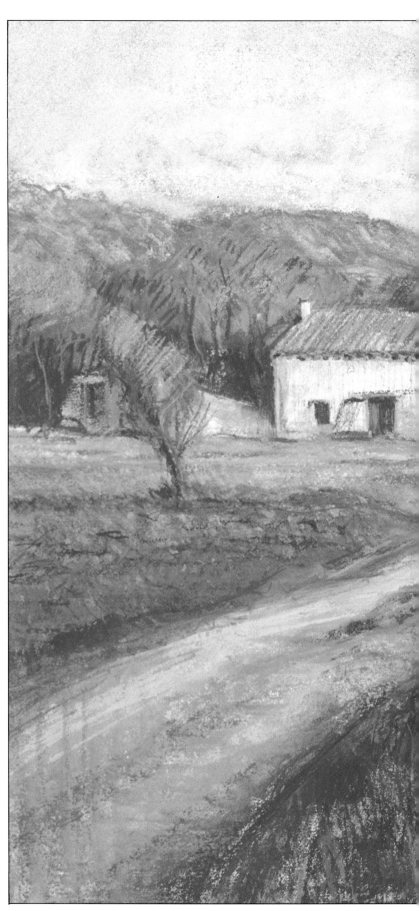

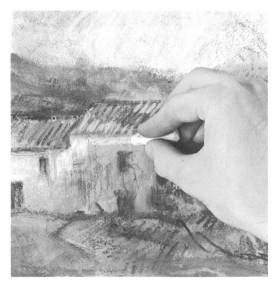

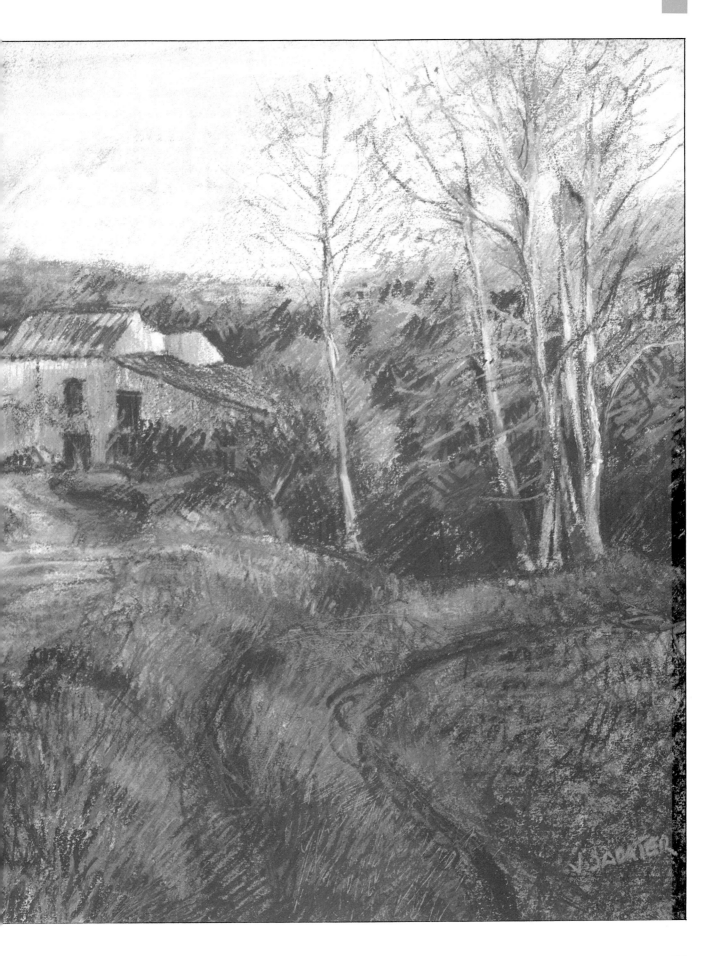

Study of a work by Degas

This work, according to its creator Juan Sabater, is intended to be an accurate and respectful study of a work by a great master Degas. The objective? To learn that it is possible to bring together the spirit of investigation and an interest in retaining classical themes.

Sabater tells us, "I must admit that Degas is a personal favorite, precisely because, with his almost poetic style, he was able to combine the two concepts: Investigation (the search for new paths) and tradition (remaining faithful to the timeless themes of art).

"I would like the reader to understand the difference between my idea of making a study and that of making a copy.

"First, I was very aware that the original picture was created in pastel, a medium of which

Degas was undeniably a master. In contrast, I have produced my study in wax crayon on white Basik paper. Initially, this imposes technical limitations, but also poses a challenge to my ability to interpret a great work of art.

"As you follow the steps I took in this absorbing exercise, I want you to retain a respect for the original work at the same time that you work boldly, without resorting to grids or any other precise measuring process. Work in an intuitive way, trying to appreciate space and form.

"There is little else for me to say, really: The few words that accompany the illustrations showing the development of my work will be more than enough for you to understand each stage.

"So, off you go—don't be afraid!"

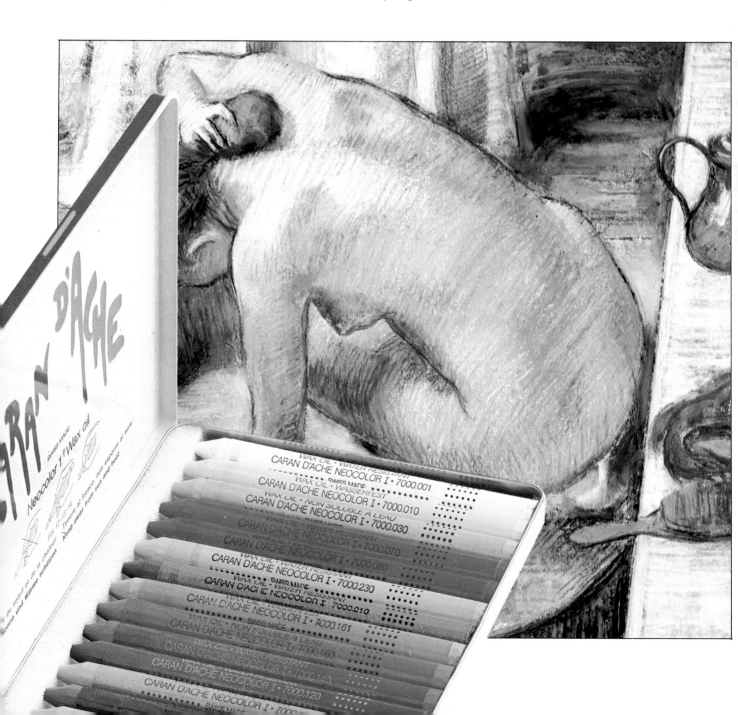

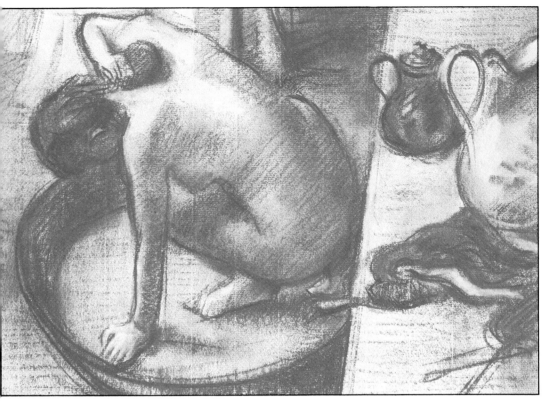

1. Preliminary study

"Having clarified my ideas, I began a study in sanguine crayon, on a $7^{1}/_{2} \times 11^{1}/_{2}$ in. $(20 \times 30$ cm) piece of Ingres paper, exploring the form, composition and tonal values of the original work."

2. Layout sketch (below)

"I made a lively charcoal sketch on a piece of Basik paper about $19^{1}/_{2} \times 27^{1}/_{2}$ in. $(50 \times 70$ cm), adapted to the proportions of the original. I tried to locate only the basic forms, feeling that the color and the tonal values are also part of the drawing process."

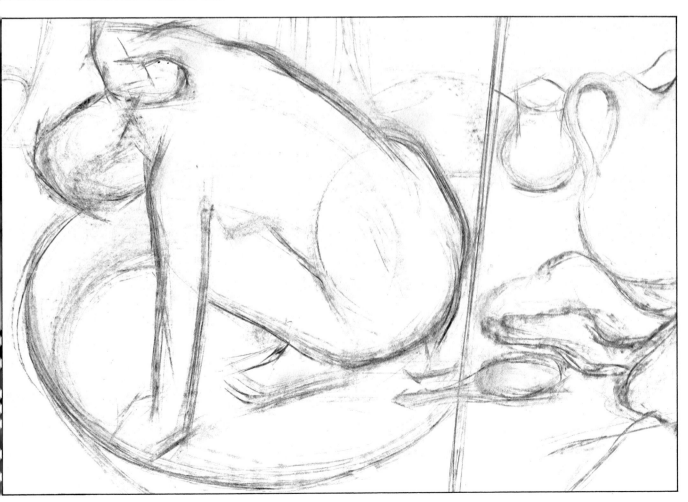

3. The initial background color

"After brushing a cloth over the outline sketch and fixing it, I started to apply wide strokes of gray crayon that I then contrasted with some touches of warm color; from the beginning these warm touches seemed important to the balance of the composition. The white of the paper helps in establishing an early feeling of volume. These close-ups show the two main ways of applying wax crayon: Holding it flat or using its tip."

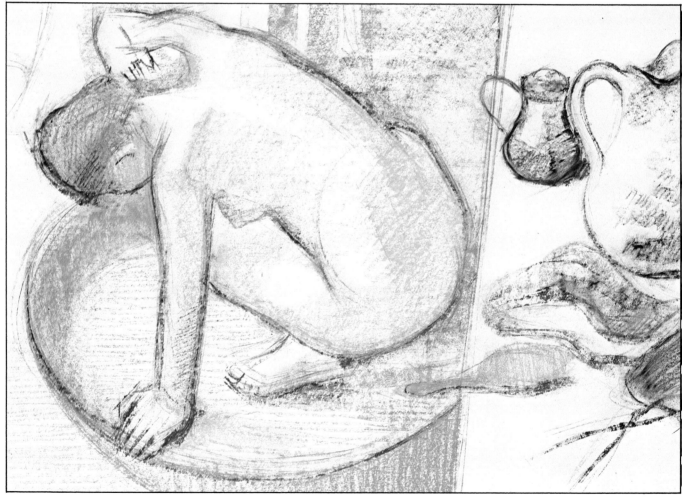

4. Applying more color

"By this time I am completely absorbed in my picture; I have built up some of the important tones that define the general shapes, and also some of the shading and projected shadows (those the figure projects on the bathtub, for instance).

"However, the most significant step is the introduction of new colors: Ochres, blues, and violets. Continually playing with warm-cool contrasts, I introduced some base color in areas that had been neglected up to this point."

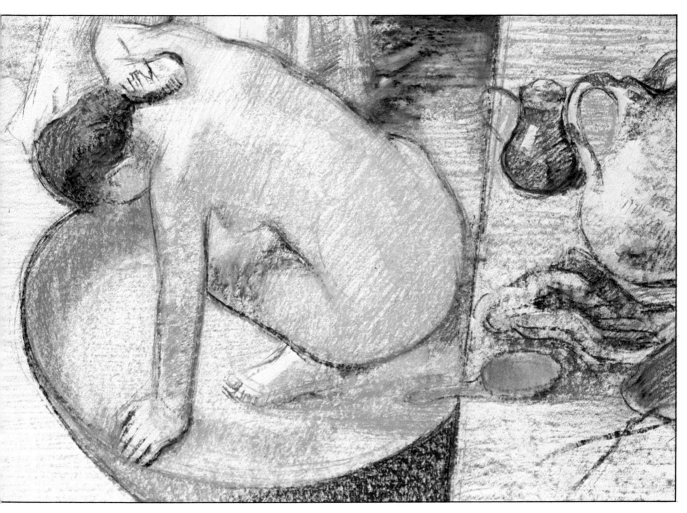

5. The first layers of color

"In fact, when I refer to layers of color, I mean vigorous strokes that leave a thicker deposit of wax on the paper. In the close-ups on the right, you can see what I am describing in the lumbar region of the figure.

"In reality, this stage is no more than a continuation of the previous one; there is no break between the two. Notice, in the close-up pictures that, to achieve total coverage of some areas, I resorted to a brush and a little turpentine."

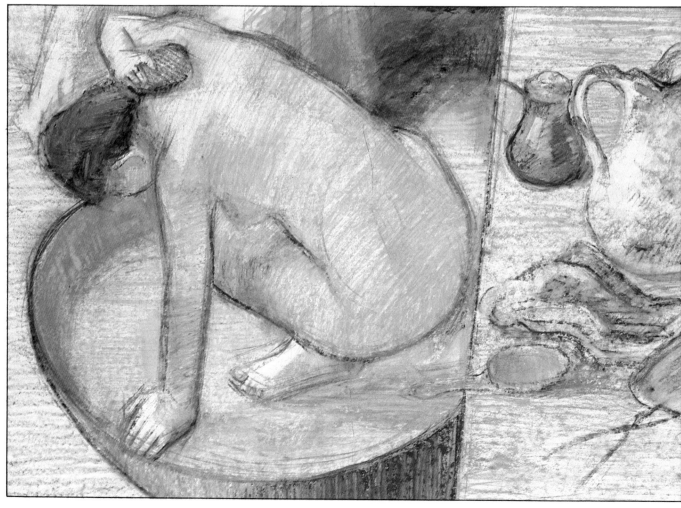

6. Balancing the color scheme

"As soon as the previous stages had given my study a certain pictorial quality, I decided to take a break. When I returned to my work, I realized that the next stage would have to consist of establishing a definitive equilibrium between the cool and warm areas. I forced myself to work confidently, without allowing myself too much time to think, outlining some of the forms and intensifying the earth colors and the violets."

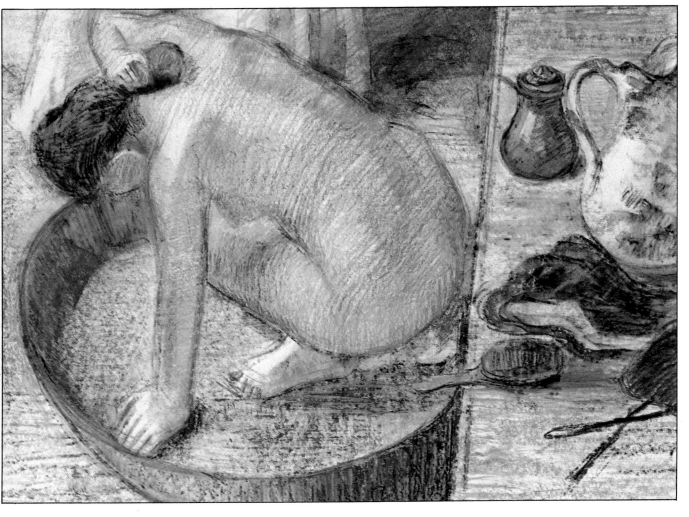

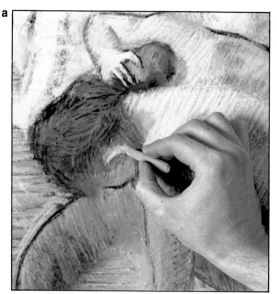

Right, close-ups
a) The gray wax crayon at work on a highlight.
b) The black wax crayon outlining objects on the dressing table to give them more substance.
c) Applying a complementary color. The blue strokes tone down the yellow and, in combination with it, produce a vibrant effect. The same thing has been done on parts of the floor.

a

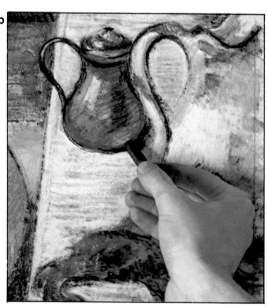

b

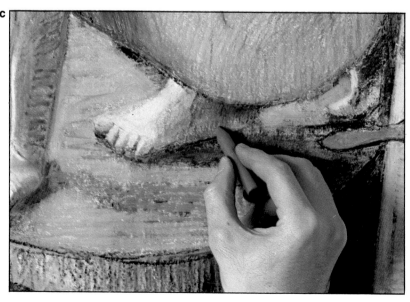

c

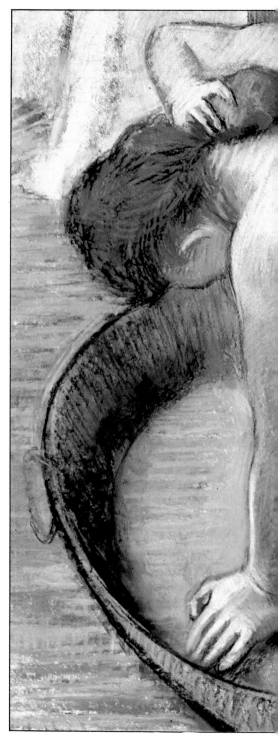

7. Nuances of color

"On top of the strong base color that dominated my study until now, I started modifying the highlights and shadows by using touches of white and gray. These helped me to create a soft and elegantly modeled figure. By applying the black outlines and complementary colors in some places (always using Degas' original as a guide), the light is more clearly defined and so, as a consequence, are the various forms."

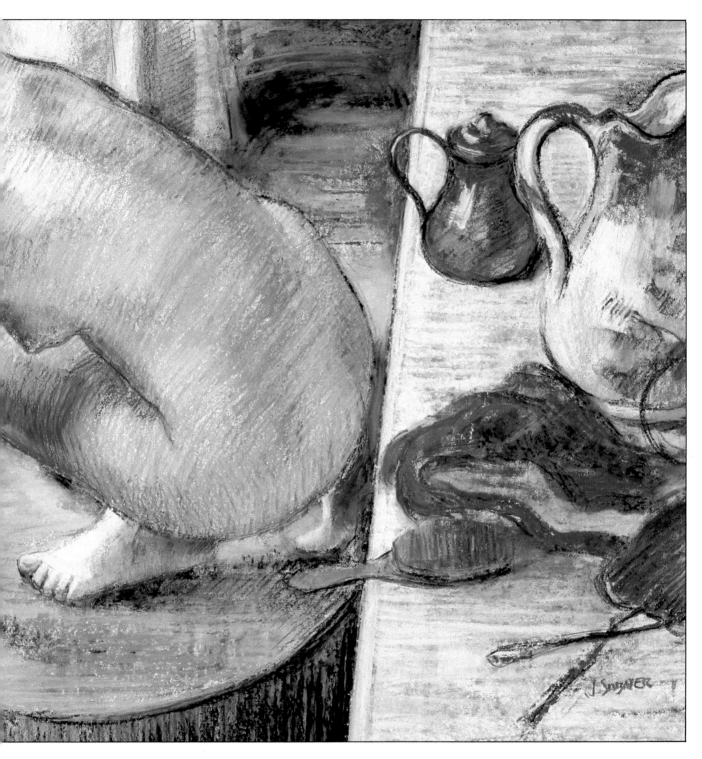

Above.
The finished study. It is interesting to see how the vibrancy of color (the quality in which different colors are seen simultaneously without losing their individual character) has been achieved by applying pigment without mixing it together. Each

color "breathes" through the one above it so that in every case there is a visual fusion, an illusion of blended color that does not actually exist.
Finally, notice the importance of the direction of the strokes in marking out the principal planes of the composition. If you

have the opportunity to study Degas' work, you will see that he is the undisputed master in applying these techniques.

■ Collage

Collage is a French word, the strict translation of which is "pasting or gumming together," and which describes the action of applying glue to a surface. It is a word that came into its own in art from the moment that traditional, academic, and orthodox concepts of artistic expression began to give way to new and revolutionary ideas. One new and revolutionary idea was the assertion that anything, as long as it had color and texture, was a valid medium for the expression of aesthetic ideas. And because these materials have to be attached to a cloth, cardboard, or wood support using glue, it is hardly surprising that French artists, who were the first to experiment with this technique, described their work as "collages."

To sum up, collage is a technique in which a work of art is created by attaching to a surface fragments of different materials, such as colored paper, magazine cuttings, photographs, and so on. Even bits of junk and rubbish may be used, such as pieces of glass, cloth, commercial packaging—anything you can think of really—in an attempt to demonstrate the expressive values of an object when it is taken out of its logical context and everyday usage.

The first collages appeared in France around the year 1912, when artists of the caliber of Picasso, Gris, and Braque began to experiment with "papiers collés." Collages made with colored paper (or paper painted by the artist himself) stuck onto fabric, card, or wood, revealed the expressive potential of this technique. It soon became widely used, first by the cubists and then by the surrealists and dadaists. More recently, collage was rediscovered by the "pop" artists and those of "nouveau realisme." There are plenty of contemporary artists around who are major exponents of collage: A. Clavé, M. Cuixart, A. Tàpies, Grau Garriga, to name but a few.

Collage with painted card

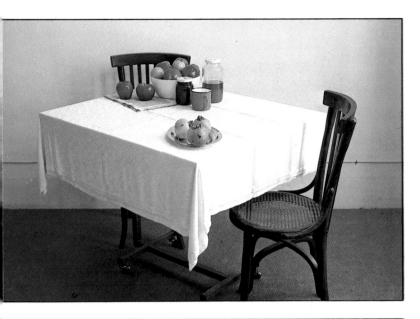

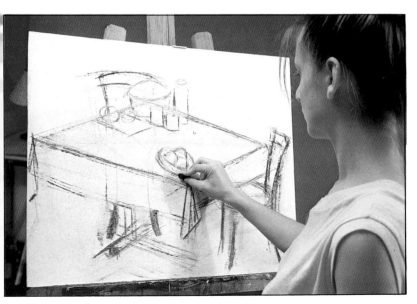

The objective of the exercise

Our hope is that you will enjoy the novelty of this exercise and throw yourself into the adventure of making a picture using the collage technique. To provide you with an example to follow, we have invited the multi talented artist Ester Serra to prepare a collage for us in her own way. Collages (and indeed most types of work created using unusual techniques) are always completely personal in the way the imagination often comes up with the most unexpected results.

Although you may not yet have a clear vision of this project, you will find your own style; you will discover your own tricks and the expressive potential of the useless scraps of paper and bits and pieces you undoubtedly have around your house.

Ester Serra's example does not mean you have to produce something similar; our hope is just that it will give you some ideas.

Ester wants to demonstrate that collage is a perfectly valid technique for interpreting traditional themes, so she is going to create a still life. She did not want to yield to the temptation of producing a nonrepresentational composition, which would have been less of a challenge.

The support she has chosen is a piece of art board about $19^{1}/_{2} \times 27^{1}/_{2}$ in. (50×70 cm) which we recommend that you also use. It is better for your first collage to be fairly large; you will find it easier than struggling to fit a lot into a small area. In the second photograph on this page, we can see Ester Serra (in an unconventional but practical position) preparing the pieces of card she will use in her collage.

Notice, in this photo and on the illustration on the previous page, that Ester prefers to create her own color and texture in the materials she uses.

As with any pictorial composition, the artist began by making a sketch of the subject. In this case, however, she made a very precise sketch and not just one to indicate the main forms. As you will see, Ester Serra works somewhat as if her collage were an illustration in one of those children's "cut-out-and-paste" exercise books.

Top. *Photograph showing the still life arranged by Ester Serra.*

Center. *The artist coloring one of the pieces of card used in her collage.*

Bottom. *Sketch of the subject. Notice the precise, linear character of this sketch.*

Paint, cut, and stick

The system followed by Ester Serra can be summed up in those words. The colors of the different pieces are determined before they are cut out and stuck on, though modifications of tone and color can always be made later. For this reason, the artist must decide beforehand which piece of cardboard (and which color) she is going to use in each part of her collage.

As we said earlier, Ester Serra constructs her collage based on the guide provided by her initial sketch. As you can see in the photographs on this and the following page, she measures, cuts, and then sticks the pieces directly onto her sketch.

The artist avoids cutting outlines that are too perfect, as this would turn the collage into a kind of machine-produced jigsaw puzzle, with all the pieces fitting together perfectly and no sign of artistic flair. Ester uses a cutting knife and scissors, but never a ruler; perfect straight lines have no place in her picture. Whenever she feels it is necessary (see the first photograph on this page), she marks the cutting edges with her fingers; to get the correct measurement for a piece of card (second photo), she uses the cutting knife taking her sketch as a guide; on other occasions (third photo), she cuts larger pieces with one of the scissor blades (not using the scissors in the usual way) to create a ragged edge.

On the following page you can see how Ester Serra uses a cutting knife to get the right shape for each piece, following the sketch lines and adding extra touches of glue to make sure it sticks. Other smaller pieces, such as the legs of the chairs, have been cut out and corrected with the scissors.

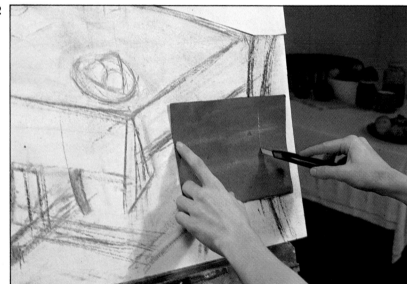

1. The artist uses the thumb and index fingers of both hands to mark out the upper edge of the card that will cover the background.

2. Marking out with the cutting knife the dimensions of the piece of brown card from which she will cut a piece for the seat of the chair.

3. In this close-up, Ester Serra cuts a rectangular piece to cover the surface of the floor.

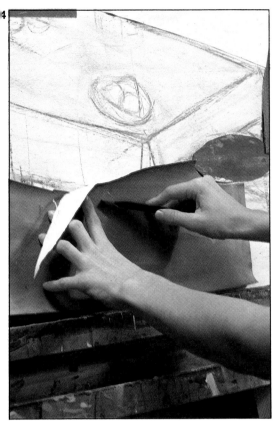

4. *The cutting knife shapes a piece of card corresponding to the floor, which will fit around the edges of the folds of the tablecloth.*

5. *Pasting down the piece of card more thoroughly. This is a process that must be carried out relatively frequently to prevent the glue from losing its adhesive quality.*

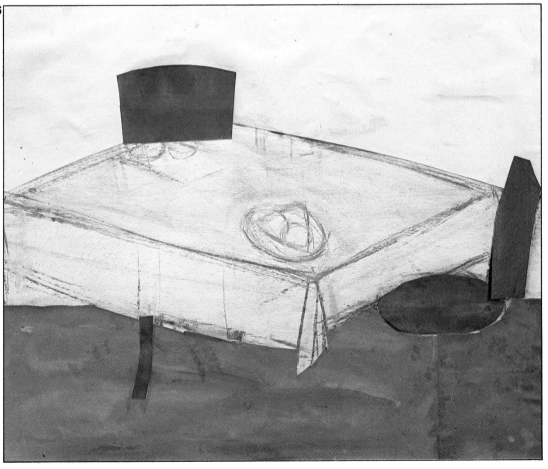

6. *The collage after the background wall, the floor and the main parts of the chair have been attached. Notice that a second piece was needed to complete the floor.*

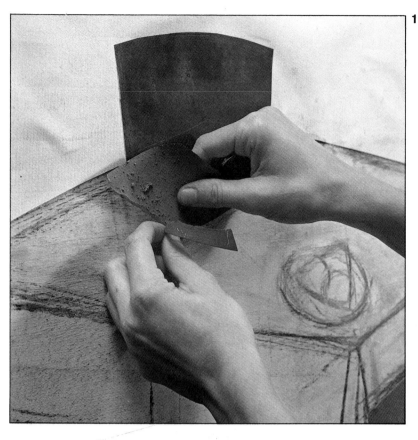

The need for imagination

Contrary to what you might think, the technique of collage is not a simple matter of manual dexterity (although this is useful, of course). A collage is still an artistic creation, although the methods involved have more to do with being skillful with the hands than with traditional painting. As a consequence, although the goal is to create a work of art, the technique is still a vehicle for the imagination. A brief analysis of Ester Serra's work is all we need to realize that the ways she finds to represent forms in collage are the symptom of a lively imagination, and are capable of giving an undeniably pictorial value to her work. Ester Serra does indeed cut out and paste pieces of colored card, but above and beyond the purely practical aspect of her work, her creative imagination is at work, making a painting out of those bits and pieces.

As the collage progresses, the artist puts into practice new ideas. For instance, it is clear that there is a world of difference between the smooth surface for the tabletop (which a beginner might produce) and the rich variety of shades Ester achieved by using different bits and textures of card. That difference indicates the presence of a fertile and original imagination.

So be imaginative in your collage! Don't be content to just cover surfaces with paper or card. Just as with a picture you paint with a brush, you should look for shades and tones that break the monotony of the uniform surfaces—except that you will need bits of paper to do this instead of paints.

In the photographs on this page you can see Ester's early attempt to introduce a richer variety of color. It is on page 124, however, that you will see how one success can lead to another, so that each step forward provides a new stimulus to the artist's imagination.

1. *Close-up showing the artist putting a red edge on the blue napkin in the top left hand corner of the table.*

2. *Applying glue to a small piece of card.*

3. *Laying down the card that represents one of the hanging sides of the tablecloth. Notice the deliberate unevenness of its lower edge.*

4. *Situating and adjusting one of the chair legs in the forefront of the picture. See also how the plate with fruit on the near corner of the table has been indicated, for the moment, by superimposing two individual pieces of card.*

5. *Close-up showing how in her collage, Ester Serra combines true collage with other more traditional techniques. The gap between the bars of the chair back, for instance, have been indicated with individual strokes of white oil pastel. A stick of chalk or a wax crayon would have done the job equally well.*

6. *Ester Serra's collage after all the stages we have just described. Up to this point the pictorial interest of the picture is debatable. If it were a normal painting we would describe it as having reached the stage of establishing the basic areas of color.*

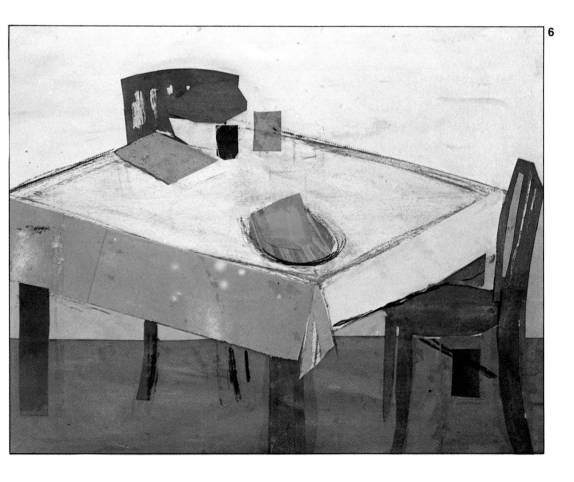

1. Ester Serra has given the tablecloth texture through generous layers of acrylic paint applied with a hog's-hair brush.

2. The artist has built up the coloring of the floor, by using various cuttings of different shades and forms, suggesting an irregular mosaic.

3. The two small pieces of white that stand out from the corner of the serviette help greatly to direct our attention toward the upper corner of the table, which is the focal point of interest in the composition.

4. The pieces of white stuck to the tabletop are effective in making this area more interesting.

5. The collage at a stage when it is unclear whether it should be declared complete or worked on a little more. Finally, the lack of contrast between the tablecloth and the wall in the background lead the artist to her final strokes of inspiration.

6. Little details suggesting the folds in the corner of the tablecloth. What did we say about using the imagination?

7. The finished work. Study it carefully and, in your own collage, try to achieve the same richness of color, tone and form that enabled Ester Serra to present us with a true work of art.

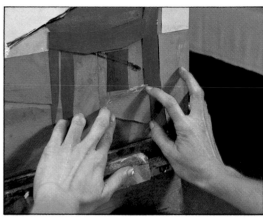

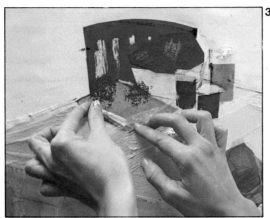

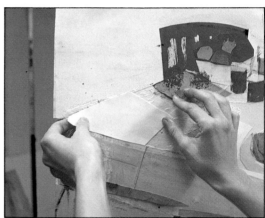

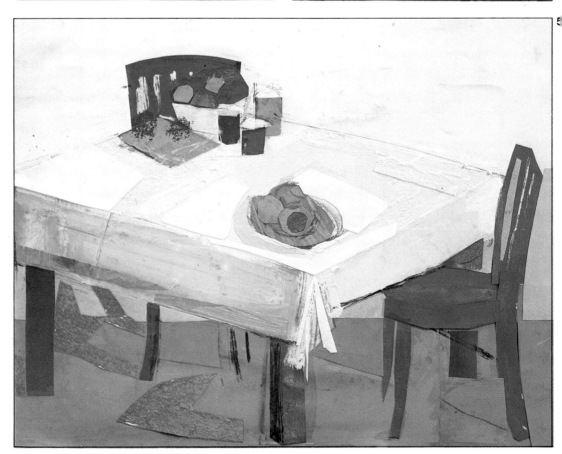

6

Final stage

On these pages we have summarized graphically the stages by which Ester Serra turned the rather ordinary collage we saw on page 123 into the finished picture that you see below.

Combining brushwork with the application of previously colored pieces of card, the collage acquired an unexpected pictorial interest so that we can now describe it as a work of art. Ester Serra has managed to produce a picture that became more than just a curiosity piece. The value of her picture lies not just in the way it was produced, but rather in the visually stimulating and descriptive image the artist produced. Collage is a pictorial process with great possibilities as well as great limitations. The relative success of this technique is dependent upon the individual artist.

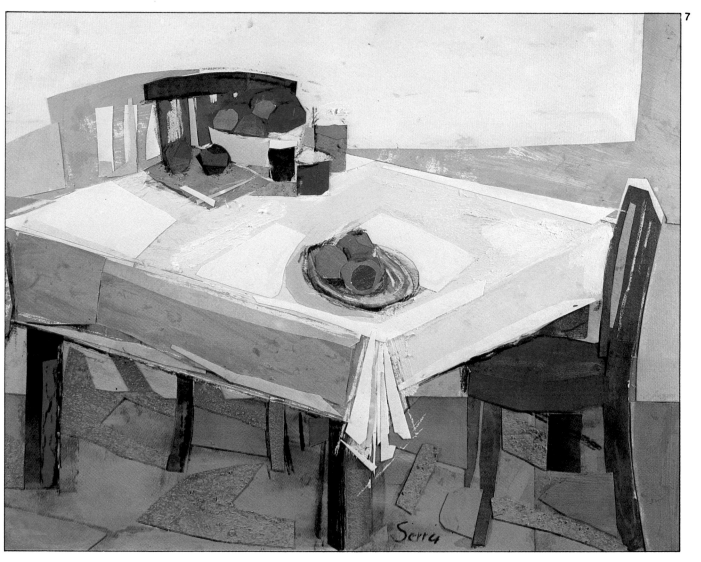

7